GHOSTS
OF THE
LAST BEST PLACE

D0113402

ELLEN BAUMLER

Haunted
America

Published by Haunted America
A Division of The History Press
Charleston, SC
www.historypress.net

First published 2016

Manufactured in the United States

ISBN 978.1.46713.615.0

Library of Congress Control Number: 2016939302

CONTENTS

ACKNOWLEDGEMENTS

No book is a product of its author alone. Without the enthusiasm and help of many, this book would not have come together. I thank those whose names appear on the following pages for allowing me to interview them and write about their experiences. It is not easy to come forward with personal experiences of a paranormal nature. The stories on these pages are important not only for the personal experiences they interpret but also for the historical backgrounds that set the scenes. In addition to those named in the chapters, I am especially indebted to the generous contributors who helped facilitate interviews, introduced me to key players and offered assistance in myriad ways. These included Donna McDonald of Upper Canyon Outfitters, Cheryl Hughes of Sentinel High School, Phil Aaberg, Nellie Israel, Trudy Skari and members of the Laas family, Janet Stellmon, Debbie Hronek of the Joliet Public Library and Betsy Kirkeby of Montana Fish, Wildlife and Parks. These folks helped enrich the stories by adding voices and photographs I would likely never have discovered without their help. I greatly appreciate it.

I thank my daughter, Katie Baumler-Morales, who read and critiqued many of the stories in the first drafts, and my husband, Mark, who always offers valuable insights and critical reviews.

INTRODUCTION
VIRGINIA CITY HAUNTINGS

This is a journey across the Last Best Place, to some of Montana's spiritually charged spaces where surprising things sometimes happen. Virginia City is a great beginning. My own experiences seem to concentrate there perhaps because its past is so familiar to me.[1] The gold rush drew a varied population of high emotion and intense energy. That is what I believe fuels the paranormal events that many experience there.

Idaho Street in Virginia City is not where tourists usually go exploring. But it is one of my favorite Montana places. I often marvel at the traffic this historic street has seen and wonder how many souls have walked in its dust. Idaho Street has its secrets. Humble ruins and high-style homes sit amicably side by side on the unpaved street. Here locals tell their stories, and I have my own to add.

The Daems House was the modest home of early day physician Levinus Daems. Its timeworn rooms, dating back to the 1860s, have been beautifully restored. The house sometimes serves as a temporary residence for state employees and other guests. I love the house and stayed there with colleagues during history camps in previous years, but this was the first time I stayed there alone.

On this summer night in 2009, I was exhausted after a long day working with middle school campers. The period-furnished house was quiet and peaceful after a day of noisy preteen chaos. But then I heard the front door open and a voice called, "I'm home!" I went to check. No one was there, but the air suddenly felt strangely heavy, like something was off kilter. I was

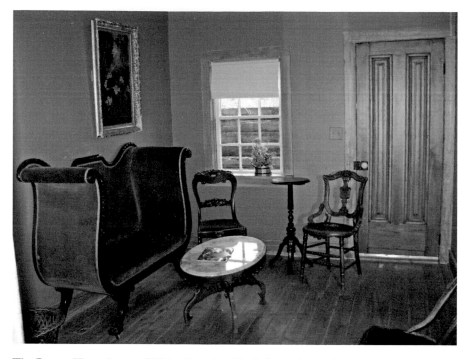

The Daems House is one of Idaho Street's spirited places. *Author photo.*

a little uncomfortable because I had written about a Daems family scandal and the article had just been published. I wondered if there were spirits in the house aware of what I had written.

I heard no more voices. The house was quiet and orderly, not like other times when multiple guests and all their stuff filled the six rooms. I thought it would be a great opportunity to take some photos, so I made a sweep of the rooms with my digital camera. Then scrolling through the photos, I noticed orbs in almost all of the frames. Some believe that orbs, bubbles of light that sometimes show up in photographs, are evidence of the supernatural. How odd, I thought.

I remember struggling to shut and lock the back door, swollen from summer moisture. The lock was especially difficult. When I was sure the door was secure, I went through the rooms pulling down the shades, turned out the lights and fumbled my way to the adjoining room in the dark. I sank into bed.

I awoke with a start around 1:00 a.m. The house was utterly silent, but something wasn't right. What was it? Then I realized that the room was no longer dark, and I did not need my flashlight when I looked at my watch.

I crept out of bed and stepped into the back room. A scream stuck in my throat. The back door I had so carefully shut and locked stood wide open. Silver moonlight flooded into the house, touching everything with an eerie metallic glimmer. I instantly knew that the heaviness—whatever it was—had gone out the door. How the door opened was a mystery.

Later that same week, I again stayed alone at the Daems House. Again I took photographs of every room, but none included orbs.[2]

The Bonanza Inn is among the haunted places I have written about on Idaho Street, but I think its energy is the most intriguing. Built in the mid-1860s as the Madison County courthouse, it served up justice until 1875. In 1876, three Catholic Sisters of Charity arrived from Leavenworth, Kansas, to convert it to St. Mary's Hospital for miners. The sisters battled cholera, typhoid, consumption, gunshots wounds, saloon fights and mining accidents. Then mining waned, and the sisters moved on in 1879.

After it was converted to a dormitory for seasonal employees in the mid-twentieth century, short-term residents began to report a female spirit at their bedsides. Over several generations of overnight guests, she soothed the sick and comforted the depressed. Some claim to have seen a shadowy nun along Idaho Street or sitting in a pew in the Episcopal Church. No one bothered to find out who she was. So I set out to discover her identity.

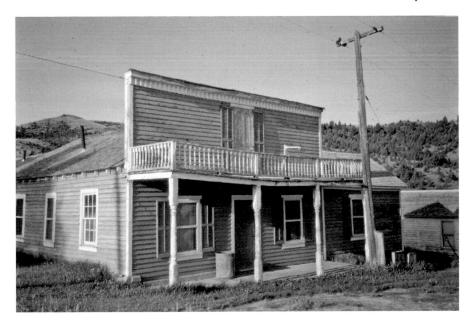

Many overnight guests at the Bonanza Inn report ghostly encounters. *State Historic Preservation Office (hereafter referred to as SHPO).*

9

One of the three Sisters of Charity was an eighteen-year-old novice who endeared herself to Virginia City. Community women, concerned about Sister Irene's safety among the rough miners, promised one another that whenever pretty Sister Irene left the hospital, one of the women would secretly follow close behind, making sure she was safe. Years later, as mother superior at St. James Hospital in Butte, Mother Irene McGrath cared for a patient who had known her at Virginia City. She told Mother Irene of the women's service. The seasoned mother superior was overwhelmed to discover this kindness. It seems logical that she would come back to Virginia City to repay the kindness.

I stayed in Room 7 in the summer of 2000. When I came out of the steamy bathroom after a shower, a strong unpleasant odor hit me, like that of the geriatric ward where I worked as a candy striper in high school. The cloying smell lingered but did eventually dissipate. Another guest in Room 7 awakened to the sound of water splashing. It kept her awake for some time. She later realized that the sisters had no running water and used basins for washing wounds and bathing patients. The splashing made sense.

The caring entity seems to favor Room 2, where one guest reported unseen hands pulling up her covers and tucking them around her. Professional paranormal investigators came to the same conclusion in 2008. One of the investigators had seriously injured his knee. He sat in Room 2 and asked the sisters to help him heal. Soothing warmth flooded through the painful area. At the same time, a digital photo captured a large orb over his knee. Later, he and another investigator heard footsteps outside Rooms 1 and 2. And that same evening, a digital recorder captured a female voice saying, "…help you?"

My own recent experience adds to the growing inventory of stories. The summer afternoon was intensely hot and the silence profound as I lay down to rest in Room 2, thinking about my lecture that evening. The outer door was locked, and I had the Bonanza Inn all to myself. At first, the footsteps were so soft I didn't notice. Then I could hear them coming closer. It was definitely a woman in sturdy shoes, down at the far end of the hallway. I heard her come closer, pausing midway down the hall. I heard a key turn in a lock. The door clicked open and softly closed. I heard a few bumps and clunks, and then more footsteps behind the closed door. Slowly they grew faint and then faded away. I am sure it was Sister Irene, paying me a visit. I felt honored.

Because of my own Virginia City experiences, I was thrilled when Donna McDonald of Upper Canyon Outfitters invited me to spend an afternoon with her friend, a professional psychic from California. "V" wanted to visit

Virginia City with someone who knew its history, to see if her impressions were historically accurate. Although she knew nothing about Montana history or Virginia City, she did not disappoint.

A small group of us began at the Bonanza Inn. V picked up on the hospital right away, noting that she felt illness in the building and a nurturing female presence, someone who made sure everyone was taken care of. "She stays here," said V, "because this is her family. They call her." V also noted a man with a stomach injury who had died in the building. She said there was something about his belt buckle.

"He was running away," she said, "wanting to start over. His family never knew where he was."

This encounter aligns with an incident from about fifteen years ago. Workers removing plaster during renovation of the building discovered a Civil War belt buckle hidden in a wall of one of the rooms.

As we prepared to move away from the Bonanza Inn, V had one more thing she wanted to talk about. She said that the building has another caretaker besides the woman: a man in a big hat, chaps and a handlebar mustache.

"This man," said V, "is overdressed, exaggerated, like he is in costume. He is very theatrical."

This fits. The Virginia City Players—Montana's oldest professional theatrical company, founded in 1949—sometimes stayed at the Bonanza Inn during the summer seasons. The group still presents vaudeville and melodrama-type performances.

As we turned to go, V stopped to make one more comment about the Bonanza Inn: "It's common for people to hear footsteps in the hallway."

We walked along Idaho Street, stopping at the Thomas Francis Meagher House. Meagher came to Montana in 1865 as the territorial secretary and soon became the acting governor. His death is Montana's greatest unsolved mystery. On July 1, 1867, he disappeared off a steamboat docked at Fort Benton. His body was never found, and many have speculated on the cause of his death. Some believe he was ill and fell, some think he was drunk and fell, some are convinced that political enemies shot him or pushed him and one eyewitness claims he jumped. As we stood in front of the Meagher House, out of the blue, V said, "He didn't always do the right thing. He understood that there were those who were trying to get rid of him." Then she moved away toward the Episcopal Church.

We spent some time in the church, talking about Mary Elling, wife of Henry Elling, Virginia City's wealthiest citizen. The Elling House, a couple

blocks farther up Idaho Street, is a beautiful Gothic-style residence still in use as a bed-and-breakfast/community center. V said that Mary had many children and not all of them lived. This made her very sad. V felt that Mary's life was difficult and that Mary wanted to bring culture to the community, but her husband dominated her. He was only interested in making money.

V was correct in her psychic observations about Mary, a former teacher. She had thirteen children, not all of whom lived to adulthood. Mary wanted to share her home with the community, but Henry would allow only the wealthy elite in the house. After Henry died in 1900, Mary built the church in Henry's memory. But she also built a ballroom addition onto her house and gave frequent parties, welcoming everyone into her home.[3]

As we walked out of the church, V stopped in the vestibule. "There's someone trying to get my attention," she said. "He's tapping me on the shoulder." Looking at me, V said, "He wants me to tell you that he is a historian, too, and he thinks you do a good job."

"What?" I stammered. "What are you saying?"

There was a wall of photos of all the Episcopal ministers who had served in this church. V pointed to one of the photos. "It's him," she said. "He's the one."

I looked at the name underneath the portrait. It was the Right Reverend Daniel S. Tuttle, who had served as bishop of Montana, Idaho and Utah from 1867 to 1886. It was he who had established Virginia City's Episcopal congregation in 1868. His book, *Reminiscences of an Episcopal Bishop*, was familiar to me. I had even quoted some of his charming anecdotes in my own writing. This revelation was quite moving.

We left the quiet of Idaho Street and headed to the center of town. I led V to the Hangman's Building, where, in 1864, five suspected road agents were hanged from the roof beam. I thought perhaps she would pick up some strong energy there. She did. V intuitively knew what had happened in the building and began to talk about the five victims.

"These men deserved it," she said. "All of them were guilty except one. I feel that one had a stomach injury. No," she corrected herself, "it was his leg. Oh, now I see. It was his foot. There was something wrong, and he limped. He was the youngest of the five. He's asking why they didn't just shoot him. He wondered why they thought he did these things. He was associated with the other four, and he knew about what they did. Yes. But he was innocent."

V then made a surprising observation. She said, "I sense there is some very strong controversy over the early history of Virginia City. People don't agree over the merits of the people who administered this justice."

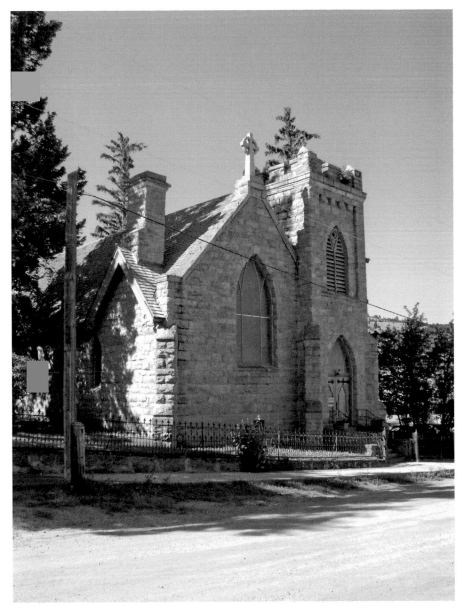

Mary Elling financed construction of the Episcopal Church in memory of her husband. *Author photo.*

Five accused road agents died at the hands of vigilantes in the Hangman's Building in 1864. *Author photo.*

She did not ask me what I thought, nor did she express her own opinion. But she was correct. There are those who believe the vigilantes were justified in their actions. Others believe they should never have taken the law into their own hands. It was incredible that an outsider with no knowledge of Montana or its history could so quickly pick up on this very real controversy, one that is quite alive even today.[4]

V's observations convinced me that the argument can never be resolved and that this may be what keeps Virginia City's past alive. Its ghosts are intertwined with questions. This is what makes Virginia City one of the best of Montana's last best places.

1

TERROR IN THE WILDERNESS

In the deep cold winters of the rugged Rocky Mountain wilderness and across the northern United States into Alberta, Canada, stories tell of starvation winters, of creatures that roam the remote backwoods and of the poor souls who have fallen victim to their fellow humans. Tales of murder, cannibalism and greed spread through the westernmost regions of Montana, too, across the scenic Bitterroot-Selway Wilderness into Idaho. The road through the wilderness area even today is one of the nation's most dangerous and remote.

In hard times when wind and snow block the mountain passes and cover the trails and game is scarce, a terrible fate can befall those who travel here. At these times, hunger can drive a person to do unspeakable things. Native American stories warn that the wendigo roams the northern regions from the Atlantic Ocean to the Rocky Mountains and as far north as the Arctic Ocean, hungry for human flesh. Most northern Native American tribes have tales explaining how a human can turn "wendigo" (or "windigo") by an act of cannibalism, through the presence of a demon, through a dream or by the sorcery of a shaman. The wendigo symbolizes the phantom of hunger that stalks the forests of the north as a shape-shifting spirit with a heart of ice.[5]

In times of starvation, the wendigo story served as a deterrent to cannibalism, a taboo forbidden even when it would save one's life. Suicide or resignation to death was preferable to turning wendigo. Assiniboines and Crees even performed a wendigo ceremony in times of famine to reinforce

The road over Nez Perce Pass is one of the nation's most dangerous even today. *Author photo.*

this taboo. Elders taught their children to behave or the wendigo would come for them.

From Algernon Blackwood's powerful 1910 short story "The Wendigo" to Stephen King's 1983 *Pet Sematary*, the mythical creature has been popularized in contemporary literature, movies, comic books and video games. But the idea is not entirely frivolous. Anthropologists have studied a phenomenon called "wendigo psychosis." There are historical cases of this condition. It results when a person under dire circumstances dines on a fellow human and afterward develops an insatiable taste for human flesh. One famous documented case was that of Swift Runner, a Plains Cree trapper in Alberta, Canada, who butchered and ate his wife and five children, even though the starving family was within twenty-five miles of food at a Hudson's Bay post. Swift Runner, suffering from this psychosis, became a homicidal cannibal. He later confessed and was executed by hanging at Fort Saskatchewan in 1879.[6]

A remnant of the belief in Montana's Bitterroot Valley has come down through the story of Sleeping Child Hot Springs. The springs and a small creek south of Hamilton are the subject of several legends. One story dates to 1877 when Chief Joseph and his band of Nez Perce came over Lolo Pass into the Bitterroot Valley fleeing the U.S. Army. They split into two groups that traveled separate routes. One group followed a small creek and discovered a beautiful hot springs. Fearing there could be a battle with the pursuing soldiers, they left their infants at the springs, where the lush vegetation along the banks could hide them. No confrontation materialized, and they returned some hours later. They found the children well protected and sleeping peacefully and so named the creek and hot springs Sleeping Child.

A much older legend, however, tells a different story. The name of the beautiful hot springs and creek was originally Weeping Child. Indians of long ago told about how travelers who passed near the springs would hear a child's pitiful crying. The sound would draw their attention, and they would seek out the source. Upon discovering a child weeping uncontrollably along the bank, the travelers would take pity, lifting the child in their arms. The

child was starving, and the traveler would offer his finger as a pacifier. But the child greedily sucked until all the flesh was gone from the finger and then from his arm. Finally, when the child had sucked all the flesh from the traveler's body, the bones would fall to the ground. The child would then disappear and lie in wait for another unsuspecting traveler to share the same fate. The hunger was never satiated, and there was a great pile of the bones of all the victims at Weeping Child Hot Springs. Local settlers renamed the springs and creek Sleeping Child, thinking it a better name for such a pastoral place.[7]

The western edge of Montana's Ravalli County follows the southern half of the Bitterroot Mountain Range across the border into eastern Idaho. Heavy forests and high mountain passes have a long cultural heritage and, sometimes, a dark past. Scarred trees in this area of western Montana and eastern Idaho are indicative of travel corridors that native people used seasonally. Majestic Ponderosa pines and, less often, western larch and other types of trees of great age served as a source of nutrition in the spring when the sap was running. Food was scarce at this time of the year, and the people were hungry. Various tribes harvested the sweet inner layer of the bark, or cambium, and dried it like jerky. Harvesting cambium did not kill the trees but did leave scars. Lewis and Clark noted the practice of peeling bark in their journals, and some scarred trees still standing today were harvested as long ago as the 1700s.

Nez Perce Pass is one of these lonely routes long traveled by native people. When gold was discovered in Idaho in 1860 and 1861 and in Montana in 1862, Congress created the vast Territory of Idaho in 1863 to include the western half of Montana. The territorial capital was at Lewiston, Idaho. Miners and traders used the Southern Nez Perce Trail over the pass as the most direct route from Elk City, Idaho, to Bannack and Virginia City, Montana. This route was a dangerous but well-traveled pack trail.

In early fall of 1863, Elk City merchant Lloyd Magruder traveled this route to Virginia City to sell a load of goods. Magruder was a well-respected citizen, recently chosen as Idaho Territory's congressional representative. His business venture to the mining camps of Montana was a great success, and he planned to return to Elk City with a load of gold dust.

While Magruder was in Virginia City selling merchandise, his good friend Hill Beachy (also spelled Beachey), who ran the Luna House, a hotel and stage stop at Lewiston, Idaho, had a horrifying nightmare. In his dream, Magruder was returning from Virginia City with a fortune in gold dust. As Magruder and his companions camped west of Nez Perce Pass, thieves

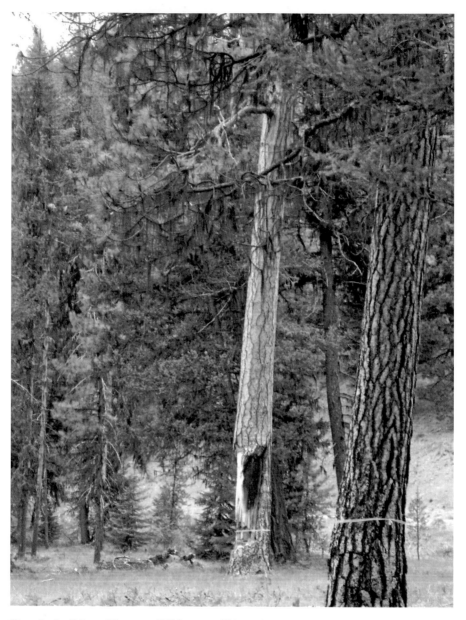

Trees in the Selway-Bitterroot Wilderness still bear the scars of harvesting. *Author photo.*

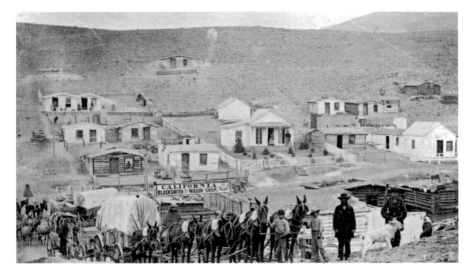

A freighter's mule team waits on Van Buren Street in Virginia City, 1866. *Montana Historical Society (hereafter, MHS) Photo Archives 956-113.*

ambushed them and killed them in a horrible manner. This greatly disturbed Beachy. He told his wife about the dream, confiding his great worry and anxiety about his friend. Mrs. Beachy cautioned her husband not to talk about it or people would think he was crazy.

Meanwhile, business in Bannack delayed Magruder's departure for Elk City. He finally set off in October 1863 with a large number of livestock and four companions. Four other travelers joined the group along the way. As Beachy's dream had foretold, the new travelers ambushed the original group west of Nez Perce Pass and killed all five. Magruder's skull was split with an axe, and his companions were killed in like fashion or shot. The murderers gleefully spent the night cleaning up the carnage. They rolled the victims in blankets and threw them into a gorge eight hundred feet deep, where wolves would take care of the remains. They burned the packsaddles, straps, rifles, pistols and everything else they did not keep; gathered the melted metal in a sack; and threw it into the gorge. The seventy or more animals they did not need they turned loose.

A heavy snow was falling, and by the time the murderers left the next morning, everything lay under two feet of snow. There was not a sign of the grisly activity that had taken place the night before. They were certain no one could discover their terrible deeds. But as they made their way along the trail, the train of pack mules they had turned loose began to follow the

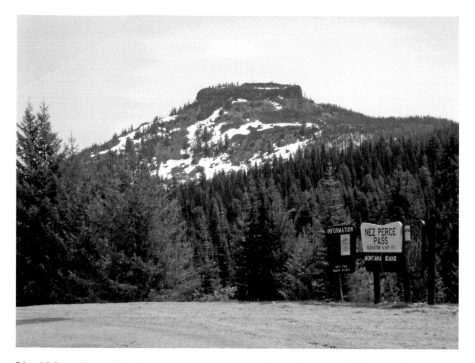

Lloyd Magruder and his four companions were murdered just west of Nez Perce Pass. *Author photo.*

tinkling bell of one of the horses, as they had been well trained to do. The heartless murderers shot some of the animals, but could not run them off. The mules kept following the tinkling bell. Finally, they drove the dozens of mules into a canyon and slaughtered them.

In Lewiston, Beachy could not let go of the dream he believed to be a premonition of his friend's death. When Magruder and his party did not return at the appointed time, Beachy feared his dream had come true. Soon after, a group of four strangers came into Lewiston behaving in a suspicious manner. Beachy suspected these men had killed his friend. They bought tickets for the stage at Beachy's Luna House and left their horses with a local rancher. A youngster who had worked for Magruder recognized his saddle among the tack, and a horse left with the rancher matched a horse that had belonged to one of Magruder's companions. That was proof enough for Hill Beachy.

Beachy hunted down the desperadoes, following their trail to San Francisco, California; succeeded in having them arrested; and brought them back to Lewiston. They stood trial and three of them were hanged

on March 4, 1864. These were the first legal hangings in Idaho Territory. Hill Beachy later visited the site where Magruder and his four companions were killed. He recovered the gruesome remains, frozen at the bottom of the gorge, and buried them. The recovered gold was returned to Magruder's family.

The remote ninety-five-mile route the ill-fated merchant took over Nez Perce Pass is known today as the Magruder Corridor. It cuts through more than three million acres of wilderness as large as the combined states of Delaware and Rhode Island. Travel along this treacherous historic corridor offers breathtaking views unchanged for hundreds of years. Its spectacular beauty is a stark contrast to the ghastly fate that befell Magruder, his companions and his pack train. In the deep dark of night, spirits surely wander along the trail that would have taken them home.[8]

While Hill Beachy's premonition and the human greed that brought about the end of the Magruder party are unfortunately real enough, not all believe the other long-ago tales told of Montana's remote places. Most of us would dismiss the wendigo as a figment of the imagination. However, Theodore Roosevelt, in his book *The Wilderness Hunter*, tells a believable story. The book, first published in 1907, includes an incident Roosevelt heard in 1893 from a seasoned mountain man named Bauman who had spent his entire life in the backwoods. Roosevelt commented that Bauman shuddered with such revulsion at certain points in his story that it was obvious that the veteran woodsman was telling the truth.

Years before, Bauman and his partner were trapping in the mountains of western Montana, between the Salmon and Big Hole Rivers. Not having much luck, they decided to follow a small stream through a pass that had a dangerous reputation. The previous year, a hunter had been killed in the area and partially eaten by some wild animal. A miner passing through had discovered the remains.

The two trappers left their hobbled ponies in a grassy meadow and hiked in some distance. They made camp and set out through the dense forest. It was dark and dismal as they pushed through the tall pines and firs. Returning to camp, they found that something had paid them a visit, scattering their belongings. They thought it was a bear until they found the tracks, apparently made not by paws but by feet. Whoever, or whatever, it was walked on two, not four.

That night, the men slept under a lean-to, rolled up in their blankets. During the night, Bauman awakened suddenly. A terrible odor struck him, strong and gamey, like some wild beast. A huge form loomed in the shadows

at the edge of camp. Bauman pointed his rifle and fired, but he seemed to have missed. The figure crashed through the woods.

The next morning, the partners again went out trapping. When they returned, same as before, the camp had been ransacked, the ground marked with tracks of a two-legged beast. The two men were very uneasy and gathered plenty of wood to build a fire that they kept roaring all night. Each took turns keeping watch. As

The trapper left everything but his rifle and fled. *T.D. Booth, "The Trapper's Last Shot," Library of Congress.*

before, during the night the creature came toward the camp, but the fire kept it at bay. For a long while, it kept its distance, several times uttering a grating, sinister moan.

Bauman and his partner decided to collect their traps and move on the next day. All morning, they felt as if they were being watched. Two armed men, experienced in the woods, had no reason to be afraid, but they were. They had only three traps left to collect. Bauman volunteered to get them while his partner went back to pack up camp. It took longer than expected as Bauman found three beavers in the traps and had to stop and prepare them. He started back very uneasy.

The forest seemed to close in on him, and it was with a sense of dread that he reached the camp. Bauman called out. There was no response. Smoke curled from the campfire, the packs were ready and everything was piled neatly, but there was no sign of the partner. Bauman shouted out again, and the shout stuck in his throat. There, against a fallen log, was the body of his partner. His neck was broken and deep marks of a beast's fangs punctured his throat. The flesh was uneaten, but evidence showed that the killer had cavorted around the body, rolling on it over and over.

Bauman stopped only to grab his rifle and fled.

The monster in the story has traits some attribute to Sasquatch, others to the wendigo and still others to a less supernatural human murderer or wild animal. In recounting this incident, Roosevelt himself speculates that with time, the horror of the experience and dread of the unknown might "attribute weird and elfin traits to some abnormally wicked and cunning wild beast; but whether this was so or not, no man can say."[9]

2

ON WILLOW CREEK

John Colter was among the men Lewis and Clark recruited for their journey into the unknown West. But those adventures and hardships pale compared to Colter's experiences after the Corps of Discovery returned to St. Louis. The wilds of Montana lured him back not once but several times, and his exploits have become the stuff of legend.

Colter was born in Virginia about 1775, and his family moved to what is now Kentucky several years later. He grew up on the frontier and was about twenty-nine when Meriwether Lewis recruited him to join the Corps of Discovery. Colter's experiences with the expedition merely whetted his appetite for the untapped West. The corps, traveling down the Missouri at journey's end, was only six weeks from St. Louis when it met two trappers headed upriver. Colter accepted a position with them and, without collecting the pay he had earned on the long journey with Lewis and Clark, turned back toward the wilderness he had just left.

Colter and his companions trapped along the Yellowstone but had little luck. Arguments among the partners and unfriendly Indians discouraged Colter, and he headed back to St. Louis in the spring of 1807. He got as far as the mouth of the Platte, where he met Manuel Lisa heading upriver to the Yellowstone. Lisa had heard of the wild country from members of the expedition in St. Louis, and he could hardly contain his enthusiasm. Again, the country lured Colter, and he turned around and joined Lisa's party.

They arrived at the Yellowstone in October 1807 and built a small fort and trading post. Called Fort Raymond, it sat at the mouth of the

Bighorn River in what is now Montana. Colter set out on a five-hundred-mile journey to find the Crows and encourage them to trade at Lisa's post. During this monumental trek, Colter came to the thermal springs in what is now Yellowstone Park and was the first to describe them.

Later that summer in 1808, Colter joined some Crows and Salish on an expedition to the Three Forks of the Missouri. The party was attacked by a band of Blackfeet, and Colter had to defend himself against them—a mistake he would pay for but could not avoid. Wounded in the leg, Colter retuned to Lisa's fort to recover.

John Potts, a fellow member of the Corps of Discovery, had joined with Manuel Lisa. In the fall of 1808, Potts and Colter set out to trap. Working their way up the Jefferson River, they knew of the danger, and were successfully avoiding the Blackfeet. But the Blackfeet were undoubtedly aware of the previous skirmish in which Colter had fought against them, siding with their Crow and Salish enemies.

A band of Blackfeet surprised Colter and Potts as they were trapping beaver near the headwaters. They killed Potts outright when he returned fire, but Colter was not so quick to shoot; he was instead captured. The Blackfeet gave him a chance to escape and provided themselves with a little

Despite his close call, John Colter returned to the Three Forks of the Missouri to trap. *Author photo.*

Blackfeet challenged Colter to run for his life. *Woodcut, "Colter Pursued by the Indians," W.R. Coe Collection, circa 1830.*

entertainment. They stripped him of all his clothing, including his moccasins. Giving him a little head start, they ordered him to run across the cactus-covered prairie. With the Blackfeet at his heels, Colter ran for his life. He was so fast that all but one of the pursuing Blackfeet fell behind. Suddenly Colter stopped, whirled around and, seizing the surprised warrior's own spear, killed him.

Colter grabbed the dead warrior's blanket and ran some six more miles to the river. He had exerted himself to such an extent that blood flowed freely from his nose and mouth, and fell onto his chest in a great red stream. He dove into the frigid water where he took cover under a driftwood jam. Although the Blackfeet searched for him, they did not discover his hiding place. At nightfall, they gave up the search, but most likely, they allowed him to escape. Colter crept out of the water, and with only the wet blanket for warmth, he headed east. Some days later, he stumbled into Fort Raymond at the confluence of the Yellowstone and Bighorn Rivers. He was more dead than alive, starving and sunburned, but he had successfully walked several hundred miles back to the fort.[10]

Colter was not yet finished with Montana. Incredibly after his recovery in the spring of 1809, he returned to the area of his capture to retrieve his traps. Blackfeet again discovered him, but this time amid flying bullets, Colter escaped unscathed. And once more in 1810, Colter returned to the Three Forks area, leading a party of thirty-two trappers up the Yellowstone to establish a trading post in the heart of what they knew to be dangerous Blackfeet country. Predictably, they were harassed, and Colter finally gave it up and returned to civilization after six years' absence.

With the help of an attorney, Colter finally collected his pay from the Corps of Discovery and, newly married, settled in Dundee, Missouri, on a small farm. But Montana still drew him. In the spring of 1811, according to biographer George H. Yater, a party of trappers came through Dundee. They were headed to the Yellowstone and questioned Colter about the West. One of them later wrote that Colter seemed to want to join them but held back because of his recent marriage.

Montana apparently still drew him, and he might have returned to Three Forks except that he died of jaundice in 1813, leaving his wife, Sally, and a son.

In 1849, some forty years after John Colter made the famous run for his life, a mountain man by the name of Jim Baker was guiding a party of trappers in the Three Forks area. At thirty-one, Baker was already a seasoned guide, having worked for the famous Jim Bridger and the American Fur Company as a young man. The area was no less dangerous than it had been when Colter had his narrow escapes.

Traffic along the Oregon Trail exacerbated the situation, and trappers needed to be constantly on guard. Baker and his party included twelve white trappers and three Shoshone Indians. They were moving on foot cautiously through the area. They built a small encampment along the Jefferson Fork of the Missouri, today known as Willow Creek, and spent some days there, but they found few beaver.

As they camped in this temporary place, they were constantly fearful of attack, and appointed watchmen among their group to stay up and warn the camp of danger. One man would keep watch until midnight, and a second would take a turn until daylight.

One of the twelve trappers was Bertram Emanuel, who had a reputation as a courageous man. He was also, however, known to be rather superstitious. His turn came for night watch, and he drew the second shift. He took his place at midnight, sitting with his back against a tree. There was a full, yellow moon that illuminated the landscape, and he could well see the panorama of the surrounding plain.

Jim Baker was a seasoned trapper and guide. *Frank J. Meyer Papers, American Heritage Center, University of Wyoming.*

Bertram Emanuel shared his experience the next morning around the campfire. *"The Trapper's Camp Fire,"* Library of Congress.

As he sat, alert, a figure suddenly appeared at some distance. Emanuel blinked and stared. The figure seemed to have come up from the ground and moved in a strange manner toward the riverbank. It was a man, pale and ghost-like in appearance. Emanuel readied his rifle and sprang to his feet. The man's back was turned as he slowly made his way toward the trappers' camp. He was completely naked and moved along the riverbank in a peculiar way. Emanuel pointed his gun at the ghostly figure and approached cautiously, thinking this intruder might be spying on the camp. The ghost— as Emanuel decided that is what it was—whirled to face him and threw his arms over his head. Emmanuel was horrified. Blood was streaming from the ghostly man's nose and mouth, falling bright red against his pale chest, covering it like a great river. Suddenly the ghost ran to the riverbank, dove into the river and disappeared into thin air without so much as a splash.

Emanuel was greatly disturbed and thought about his experience for the rest of the night. The next morning, the trappers gathered around the campfire. Emanuel, badly shaken, told his companions in detail what had happened. One of the trappers declared that he knew the ghost's identity. He told the group that they had camped in the area where Blackfeet had killed John Potts and forced John Colter, stripped of his clothing, to run for his life. Another member of the group had also heard the story and

agreed that this was indeed the same place. He believed that Colter's ghost was warning them. The men hurriedly packed their gear and departed, marching at a fast pace.

It was a good thing they left their campsite when they did. Three Crow Indians later told the trappers they had barely missed Blackfeet traveling past on the river. The place on Willow Creek where Potts was killed is still known to local old-timers.[11]

John Colter obviously found the lure of Montana nearly irresistible. Time and again, he returned to the Three Forks area, flaunting the danger he knew awaited. Given another opportunity, had he lived, Colter might have jumped at the chance to relive his most challenging adventure. Willow Creek might be just the place for his spirit to roam.

3
GHOST ON THE LITTLE ROSEBUD

John Stands in Timber was six years old in September 1890, when he witnessed a terrible, highly charged and tragic event. Two young Cheyenne warriors came galloping down the hill above the Northern Cheyenne Reservation agency at Lame Deer. Soldiers, dismounted, formed a line at the bottom of the hill, where they waited for the pair with rifles ready. One of the young men, Head Chief, stood accused of the murder of a white teenager. He had admitted to killing the boy and knew that he would hang for the crime. The other, Young Mule, orphaned when his Cheyenne parents were killed during conflict with the U.S. Army, attached himself to Head Chief. Rather than give themselves up to authorities to die an ignoble death, the two faced their accusers in a traditional act of bravery. It was the last engagement of the Northern Cheyenne with the U.S. military.[12]

The Northern Cheyenne Reservation was created in 1884. At that time, non-Indians ranched and homesteaded on reservation land. The buffalo were gone, game was scarce and the survival of the Northern Cheyenne depended on the government rations they received every two weeks. Not only was it difficult for families to make the food last until the next ration day, but soldiers also pilfered much of it. Furthermore, often what the army distributed was rotten and wormy. The Northern Cheyenne were starving. Sometimes, they killed cattle that did not belong to them and conflicts arose. Two of these confrontations led to murders in the spring and fall of 1890.

The first incident was the murder of Robert "Bob" Ferguson, who had a ranch near Kirby along the Little Rosebud, a tributary of Rosebud Creek.

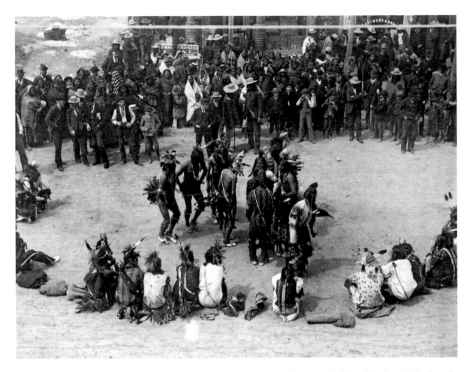

Montana Cheyenne, here in the Great Omaha powwow dance at Miles City in 1891, faced terrible hardships. *Library of Congress.*

With his brother and sister, he ran 150 head of cattle and a small band of some twenty horses. Eastern Montana ranchers worked hard, and their ranches were usually isolated. Social events thus drew residents from miles around. Nannie Alderson wrote in her reminiscence, *A Bride Goes West*, that she met the pleasant young bachelor several times at local dances. He was tall, fairly prosperous and respected among the local ranching community. During the winter of 1890, he had remarked to the postmaster at Muddy Creek that several of his cattle had gone missing. He speculated that starving Cheyenne were responsible.

Around May 6, Ferguson went out looking for some stray horses. When he did not return after several days, his brother searched unsuccessfully and then put out the word that Bob Ferguson was missing. Soldiers and Cheyenne scouts from Fort Keogh eventually joined the search. A white man who understood the language overheard two Cheyenne scouts instructing their fellow searchers to stay away from a certain area. When he informed the soldiers of the scouts' communication, they decided to concentrate

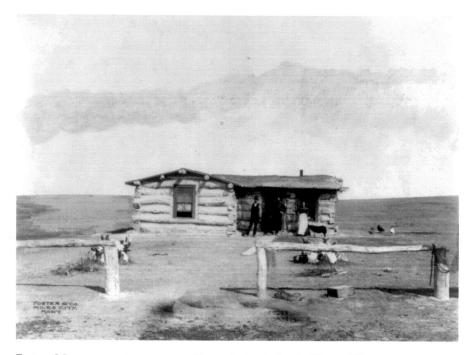

Eastern Montana ranches were primitive and often isolated. *Library of Congress.*

their efforts at that area. Circling vultures led searchers to the bottom of a draw, where they found Ferguson's horse shot to death. The remains of a butchered steer lay nearby surrounded by many moccasin tracks. The implications were clear, but there was no sign of Ferguson's body.

A few days later, stock detective Billy Smith, along with a company of cowboys on the lookout for Ferguson, came across the hiding place where the body had been buried. In a dry gulch where Rosebud and Sarpy Creeks divide, some six hundred yards from where Ferguson's horse had been found, one cowboy noticed finger marks on the sides of the draw where the dirt had been scratched down. Poking around the red shale, the cowboy hit something hard. It was Ferguson's boot. His body, wrapped in a coarse blanket, was lying beneath several inches of dirt. He had been fatally shot through the chest.

Four Cheyenne scouts were arrested for Ferguson's murder: Little Eyes, Black Medicine, White Buffalo and Powder-on-the-Face. All four protested their innocence, but a search of Little Eyes's and Powder-on-the-Face's lodges produced Ferguson's key ring and pistols. They claimed they found Ferguson's belongings on the trail and did not know to whom they belonged.

The four men stuck to their stories. A thorough investigation proved that Little Eyes, Black Medicine and White Buffalo were all at Fort Keogh at the time of the murder, so they could not have been guilty. All four were released for lack of evidence, sparking outrage among local ranchers.[13]

Weeks later in September, Head Chief was courting Goa, the daughter of a chief named American Horse. Head Chief was a hot-headed young man. Some accounts say he was seventeen and others claim he was in his early twenties. He was a troublemaker by all accounts, discontent because he was unable to prove his manhood in warfare. John Young Mule, who had been to boarding school and spoke English, was his constant companion. Head Chief wanted to prove himself to Goa, whose family was hungry. So he promised her he would bring her meat.

Head Chief and Young Mule set out on a hunting trip, but they had no luck and instead shot a cow. Fifteen-year-old Hugh Boyle came on them butchering the cow. Boyle was from Champaign, Illinois, and had come out west during the summer to visit relatives at the Gaffney/Lynch homestead. It was his job to bring in the milk cows in the evenings.

He came on the two Indians just as they had finished butchering and loading their ill-gotten meat. Boyle supposedly remarked, "I see a hungry dog snapped up one of our cows."

Head Chief spoke no English, but Young Mule translated, "He calls us dogs."

Head Chief became very angry and shot young Boyle off his horse. He then galloped by and blew off the top of his head. John Stands in Timber later wrote that they found most of the teenager's brains afterward in the red cap he was wearing. The two carried Boyle's body to a high hill and buried him. According to Stands in Timber, Head Chief covered Boyle's face with a handkerchief so that it would not get dirty, a detail the Cheyenne long remembered.[14]

By the time Chief Head and Young Mule returned to American Horse's camp, Boyle had already been reported missing, and soldiers had discovered his dead horse and bloodstains where the teen was shot. Stands in Timber was traveling by team with his grandparents to the agency at Lame Deer for ration day and passed by the site of the murder. He recalled that the horses "shied and snorted at that bloody place on the side of the road."

The Indians feared that their camps would be attacked by whites in retribution. They had good reason to be afraid. The *Helena Independent*, reporting Boyle's death on September 13, 1890, noted that the murder was committed "to show whites that the Indians could with impunity kill whites."

While this was not true, whites were ready to take matters into their own hands to find a solution: "And therefore all men in that vicinity who do any riding sling a Winchester across their saddles."

Hearing how volatile the situation was, Head Chief admitted his guilt to American Horse and asked him to go to the agency and tell the authorities that he was guilty. He would not give himself up to die an undignified death, "hung like a dog."

Head Chief said, "Tell them I will play with the soldiers on ration day outside of town. I will die like a man." Young Mule, who was not guilty of the murder, counted Head Chief as his only friend. Having no family and no one who cared about him, Young Mule volunteered to ride with Head Chief.

Head Chief's father went to the agency at Lame Deer and tried to negotiate, offering many ponies in exchange for clemency. Indian agent James A. Cooper refused. The father then said that the boys would come not to give themselves up but to fight. They expected to be killed. He would help them put on their war bonnets and tie up their ponies' tails. "Suicide by police" offered the two young men a chance to die honorably.

As the appointed time drew near, a detachment of troops and Indian police waited. Many Northern Cheyenne milled about, as it was ration day. Everyone knew what was about to happen. Soldiers rode among the crowd warning them not to fire guns or provoke action as the situation could easily explode. Head Chief and Young Mule positioned themselves at the top of the hill known today as Head Chief and Young Mule Hill. Their goal was to ride through the line of soldiers. Galloping down the steep incline, the two young men circled the soldiers and again started up the hill as bullets whizzed by. Head Chief made it to the top, but Young Mule's horse was hit and so severely disabled that Young Mule had to lead him. Head Chief donned his grandfather's war bonnet and again galloped down the steep incline to meet the soldiers. Although hit several times, he stayed on his horse through the soldiers' firing line before he fell off. An officer then shot him in the head. Young Mule was not so lucky. His horse was unable to walk, so he ran down the hill on foot, dodging bullets, stopping once to return fire. He then took cover in a brushy hollow where he was killed. Bullet scars were visible there for many years after the event.

The bodies were recovered the next day and taken to the camp of American Horse. John Stands in Timber viewed the remains, recalling that the two looked as if they were asleep. A feather had been shot from Head Chief's war bonnet that someone attached to a rock where it fell, marking the place where Head Chief died. Rain and snow and wind finally set it

free. The two were buried high above Lame Deer, near their death sites, the graves covered by timber that eventually rotted and exposed the bones. More than half a century later, Stands in Timber claimed that Head Chief's skull with two bullet holes was still visible.

The murders of Bob Ferguson and Hugh Boyle and the death charge that took the lives of two young men were closely intertwined. Ferguson's murder officially remains unsolved. However, oral accounts handed down among the Cheyennes say that night before Head Chief's death, he claimed that he had killed thre. One was Hugh Boyle, but the other two are unknown. One of twn victims could have been Bob Ferguson. We will never know fo.

In 1903, the *Billings Gazette* and the *unty News* reported on the aftermath of one of these horrific events.[15] Ag to a longtime Rosebud County resident, soon after Bob Ferguson's muis sister sold the ranch to a man named Beattie. It was a desirable propeell watered by fresh springs, and Ferguson had added outbuildings and ale. One night not long after the Beatties moved in, the couple had settleinto sound sleep. In the deep, dark of the night, there came a sudden loud, insistent rapping on the door. It jolted them awake. Thinking someone was in dire trouble, Beattie leapt to the door and flung it open. No one was there.

The Beatties began to experience these disturbing interruptions nightly. The loud rapping would awaken them, and Beattie would rush to the door and fling it open. There was never any earthly visitor standing at the threshold. Mrs. Beattie was not a timid woman, and she spent much time alone at the house as her husband often was away. She had no hesitation in opening the door to the nighttime rapping, but no one was ever there. It was frustrating and unsettling to say the least. Mrs. Beattie declared to her neighbors that that there was something very wrong with the ranch. The Ferguson ranch was located on prime, desirable land;

HAUNTED BY DEAD COWBOY

STRANGE STORY ROSEBUD COUNTY MAN TELLS.

INDIANS WERE HIS SLAYERS

Ghost of Bob Ferguson Nightly Visits Ranch Where He Lived Years Ago.

No family stayed long at Bob Ferguson's ranch. *From the* Billings Gazette, *January 16, 1903.*

Beattie thought perhaps someone who wanted to drive him away, forcing him to sell out, was playing a trick on him. He was not about to give in to some trickster. Nor would he give up the ranch to some vindictive ghost, if that was the cause of the problem.

So Beattie hung onto the ranch and his wife stood by him. But then Mrs. Beattie died, time passed and Beattie married again. The second Mrs. Beattie also experienced the rapping. It became clear that something was definitely very wrong with the place. Finally, the Beatties sold out to the government in 1900, when the boundaries of the Northern Cheyenne Reservation increased.

Rivalries sprang up over the Ferguson ranch, and many Cheyenne applied for the highly desirable land. The family who secured the property was thrilled and moved into the house. The mysterious, troubling nighttime rapping immediately began again, plaguing the new family. They did not stay long, nor did the next occupants, nor the ones after that. Finally, by 1903, it was obvious that no one could live on the property. The buildings were abandoned, and Bob Ferguson's handiwork began to crumble back to the earth. Today, no door remains for the restless spirit to rap on, and there is nothing to mark the spot where the haunted ranch used to be. If Bob Ferguson's restless spirit still roams the coolies and draws searching for his stray horses, his lonely ghost disturbs no one.

4

SPIRIT IN A SNOWSTORM

You can never predict when moments in time will turn into very special memories. One of those extraordinary times came about for me during the Eleventh Annual Storytelling Roundup in Cut Bank, Montana. It was April 30, 2005, a Saturday, and storytellers and musicians had gathered in the local high school to perform in their scheduled time slots. I had told my last ghost story, and my unsold books were crated up and ready to load in the car. I was anxious to get on the road for the long drive back to Helena to enjoy what was left of the weekend.

A gentleman approached me and asked if I had time to speak with him. I weighed the options and intuitively made a mental note to put aside my hurry and give this man my attention. We found a bench in the school lobby and sat down. I had the presence of mind to take notes as he shared one of the best and most genuine, heartfelt stories I have ever heard.

He introduced himself as Lane Kennedy, a local rancher, and told me that some years ago he had had an experience that he had always been reluctant to share. He seemed a little nervous, yet there was urgency in his voice. He said he wanted to tell me about this incident because he thought that I would not laugh and would treat his story with respect. I was surprised that he would seek me out, much less say such a thing. So I felt honored, and obligated, to listen.

Lane spent his childhood on the Blackfeet Reservation, in the shadow of what Montana's native people have always called the "earth's backbone," the Continental Divide. Before the Great Northern Railroad bisected

Chief Mountain dominates the landscape northwest of Browning. *Library of Congress.*

the prairies, before reservations divided tribe from tribe, vast herds of buffalo provided sustenance for the people of the plains. Chief Mountain to the northwest and the Sweet Grass Hills to the northeast—significant landmarks—did not belong to the people. Rather, the people belonged to them. In places like that, the great expanse of Montana's Big Sky instills an awareness of the ageless land and the tiny speck on the great timeline that marks individual existence.

Lane grew up with these traditions, knowing what life was like for the Blackfeet before the reservation and disillusioned with the present lack of opportunity there. He was, however, proud of his unusual family roots. Half Blackfeet and half Irish made an odd combination, and he relished it. As a young man, he had been restless and only wanted to get away. Lane served in the Korean War, and in the 1950s and '60s, he followed the rodeo circuit. He rode mean broncs bareback and did well. Wanting to strike out on his own somewhere new, Lane settled in California, where he spent twenty years in the construction business. Upon retirement in 1974, homesick for Montana, he came back to his Indian roots to run a few cattle on a small ranch near Browning.

When an accident left Lane with a broken pelvis, the doctor advised that in time he would become severely arthritic if he didn't walk every day to

Blackfeet reenact a war dance on the reservation at Browning, where Lane Kennedy grew up. *Library of Congress.*

keep himself in shape. So Lane figured there was one way to make himself walk. He invested in a flock of sheep, thinking that herding them every day would help him get his daily exercise. "Little did I realize," Lane joked, "that the spring lambing would rob me of many a good night's rest."

And so it was in the darkest hours of a deep cold March night in 1989, as the wind howled and the snow fell thickly, that Lane worked with a ewe's difficult birth. Finally, all was well, and he wearily made his way back to the house, where a pot of hot coffee waited to revive him. He had been hard at work for many hours, and the cold had seeped through his clothing. Lane thought to himself as he trudged up to the house in the bitter weather, "I'm getting too old for this activity."

As Lane approached the house, his eye followed the driveway down to the end, where a closed gate marked the entrance to his property from the highway. He thought he saw something. He peered through the blizzard, straining his eyes. Yes, there it was—the vague outline of a human form, barely visible through the blinding snow. A man stood there, arms folded as if he were trying to protect himself from the biting wind. He was just standing there as the snow swirled around him. Lane asked himself where the guy had come from, thinking maybe he came off the road and needed help. But why would anyone with any sense stand outside in the middle of a blizzard? From what Lane could see, the man had no flaps over his ears, no gloves, not even a coat.

"C'mon, man. Come on in the house," Lane called. "You're going to freeze."

The man did not react. Lane made his way down the driveway, closer to the figure. When he was some twenty feet from him, the stranger slightly turned, and the man's features came into better focus. Lane could then see a long black queue that hung down the middle of his back, past his waist. A small black skullcap sat on his head, and he wore a black serape-like covering. Lane again yelled at the man to come on up into the house. As he moved closer, the stranger smiled ever so slightly. Then he turned and took off, running into the swirling snow and disappeared.

"Weird," thought Lane. "Where could that man have come from?" Such an encounter in the middle of the night, in a blinding snowstorm, was strange enough, but a Chinese guy? In Browning? It seemed so unlikely.

When Lane finally fell into bed, exhausted as he was, he couldn't sleep. The figure down by the gate haunted him. What was he doing out there in a blizzard without a coat? All night, Lane tossed and turned, wondering where he came from and what he wanted. The next morning, he searched

for footprints, an abandoned car or anything that might explain the man at the gate. He found nothing. It would have been one thing if the encounter with the eerie Chinese visitor had been an isolated encounter. But as it turned out, it was not.

One night soon after the incident down at the gate, Lane was in his bedroom preparing for bed. His wife, Leta, came rushing into the room as if something were after her. The words tumbled out, "There's someone in the house, and he followed me down the hall!"

Lane hurried out into the hallway. He caught a fleeting *swish* as a figure, dressed in a black serape-like jacket and sporting a long queue, disappeared around the corner into the living room. It was the same figure he had seen down at the gate; he was sure of it. Lane bounded down the hall and rounded the corner into the living room. No one was there. He was, however, certain about what he had seen. He took little comfort in the fact that Leta saw the figure, too.

These encounters were so disturbing to the Kennedys that Lane sought the advice of Merlin Harwood, a tribal elder. Lane explained how the sighting had been very disturbing and that he had been so worried about the man out in the blizzard. He described how he had repeatedly yelled at the man to come inside and get warm. Then he told Harwood about the Chinese visitor's appearance in the house. Harwood began to chuckle.

Lane Kennedy, on his ranch near Browning, returned to his roots. *Courtesy Lane Kennedy.*

Lane was taken aback. "What's so funny?" he asked. "I'm serious about this. This situation is no laughing matter."

Harwood said that he had done some research and knew a few things about the Kennedys' property. He explained that as the tracks of the Great Northern Railroad inched across the prairie in 1891, work crews camped near the site that would, in 1895, become Browning, agency headquarters for the Blackfeet Reservation. On the little flat where Lane built his house, Chinese laborers camped. Another camp of Irish laborers was nearby. The Irishmen got to drinking, raided the Chinese camp and a fight ensued. At least one Chinese worker was killed.

Merlin Harwood's research underscored a chapter in Montana's past that is not very well known. Thousands of men from the province of Guangdong, China, left their families to follow the western gold rushes in the nineteenth century. Gold discoveries coincided with civil war, famine and overpopulation in this southern Chinese province.[16]

As placer mining dwindled in Montana and elsewhere, the Chinese role shifted to the building of the transcontinental railroads. While the Northern Pacific Railroad recruited fifteen thousand Chinese to lay the tracks across Montana and the Northwest in the early 1880s, fewer of this ethnic group worked on the Great Northern Railway across the nation's upper tier a decade later. Because of the 1882 Chinese Exclusion Act, Chinese laborers were not allowed into the United States. Japanese workers, for the most part, replaced them in the 1890s. However, the Great Northern did employ some Chinese workers.

Discrimination against the Chinese, coupled with the dangerous work in mining and construction that they were hired to do, caused grave concern for these men so far from home. It was a terrible thing to die in an unfamiliar place where no family members could tend one's grave. Those who could afford it bought insurance from "bone collectors," who periodically made sweeps across the West, exhuming remains to send back to China. But for the unfortunate men without that insurance, who remain buried in unfamiliar territory, the Chinese believe that there is no eternal rest. Those spirits can never be at peace.

"Don't you see," said Harwood. "You invited him into your house, didn't you? Well, he came in all right. And he probably knows you are part Irish. Your fellow countrymen were responsible for his death. I would make amends if I were you."

Lane had little knowledge of these Chinese sojourners, and he worried greatly about what to do. He called his parish priest and explained the

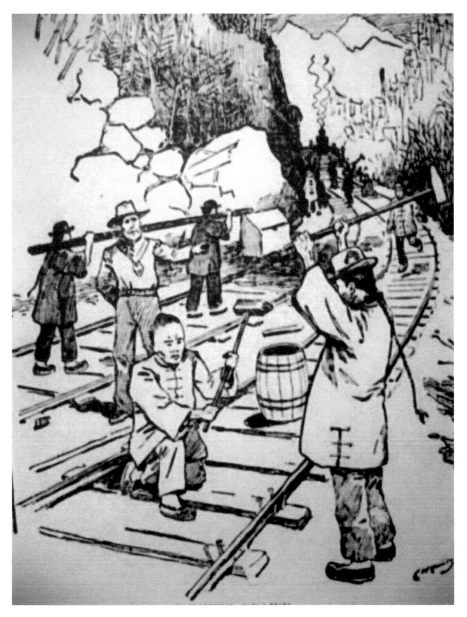

Thousands of Chinese helped build the railroad across the American Northwest. *From the* Anaconda Standard, *March 21, 1897.*

situation to him. The priest suggested that Lane should take responsibility for the tragedy that happened on his property and that the Kennedys should make amends. To do this, the priest advised Lane and Leta to stay up late and pray for their Chinese "guest." Perhaps they could, through prayer, put him to rest.

That night Lane and Leta took the priest's advice. They stayed up late and prayed for the soul of their uninvited visitor. The next morning, Lane went down to unlock the gate across the road. He was astounded at what he found. Hanging on the gate were two mule shoes. There was no sign of how they got there, but Lane had no doubt. They were the spirit's way of saying that he had heard their prayers.

Lane and Leta periodically prayed for the soul of the wandering Chinese. The morning after the second time they prayed, Lane went down to unlock the gate. A brand-new nineteenth-century horse picket was hanging on the gate.

"I have seen hundreds of these old pickets—the kind with a ring at the end that screws into the ground," said Lane, "but I have never seen a new one until this one appeared at the gate."

A few weeks later, the Kennedys prayed for the lost soul a third time. The next morning when Lane went down to unlock the gate, he found an old rusty knife and fork in the exact spot where the Chinese visitor had first appeared.

At this point in the story, Lane's voice trailed off. He couldn't just stop there. I wanted to hear the end and asked him, "What happened? Did you put his soul to rest?"

"Well," said Lane, "It's like this: Leta's mother refuses to enter the house because she says it's haunted. And the truth of the matter is that every once in a while, we'll be sitting on the couch in the living room watching television, and a little wisp of the Chinese visitor will kind of *swish* across the room."

For the Kennedys, the Chinese belief rings true. Proper burial in homeland soil might be the only way to put his wandering spirit to rest.

5

VOICES IN THE DARK

The soaring stone towers with their graceful windows and blocky turrets look like a medieval castle in a fairy tale. The impressive architecture, however, hides an awful history. Thousands of men, and many women, did time inside the high stone walls that loom over Main Street in Deer Lodge, Montana. The historic prison, active from 1871 to 1979 and now the Old Montana Prison Museum, beckons visitors to explore its secrets. If you visit the museum, the power of the past inside the walls and deserted buildings can be overwhelming.[17]

Former corrections officer Bill Felton often accompanied inmates from the new prison to the old facility on work detail and thus spent a fair amount of time within the historic walls. He believes it is a place of despair. Although some died there, most men did their time and got out. "While they were there," says Felton, "the prison took their souls." It is not surprising that the former prison is one of Montana's most haunted places.

Convicts built the imposing stone walls and the tall towers, completed in 1894. It was an unprecedented achievement, and the Montana State Prison became a model for other states. No one, however, could tell by looking at the outside what it was like to be inside.

The first cell house, completed in 1896, had room for two hundred prisoners and was immediately overcrowded. There was no plumbing. Each cell had one bucket for water and another bucket for use as a toilet. It was sweltering hot in the summer and freezing cold in the winter, but no matter what the season, the building carried the stench of human waste. Inmates

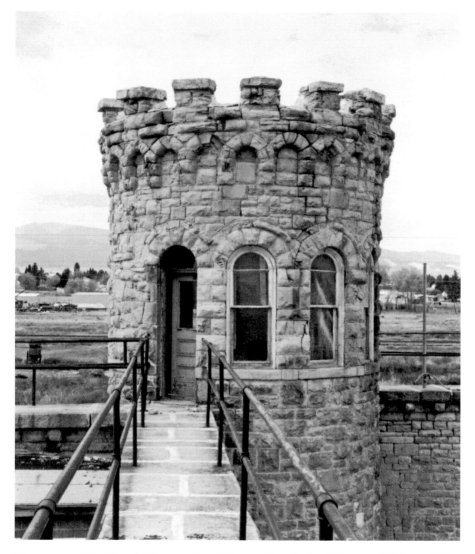

The towers of the historic Montana State Prison at Deer Lodge hide an awful history. *J.M. Cooper photograph.*

lived in these awful cells until an earthquake damaged the building in 1959. It was then finally demolished, and only memories of its cruel past remain.

The second cell house, built in 1912, still stands. Each of its two hundred double-occupancy cells at least had a sink and toilet. Four tiers of gray steel cells, stacked on top of one another, are awesome and intimidating. Prisoners locked in these tiny cells were nothing more than numbers. The air is still ripe with their despair. When the cell doors open and slam shut,

the clanging echoes eerily through the vast spaces. Living humans, however, do not always make these sounds. Both tour guides and visitors sometimes hear the cell doors clang on their own. No guards have patrolled the halls since 1979. Yet footsteps of men in heavy boots sometimes sound in the empty building.

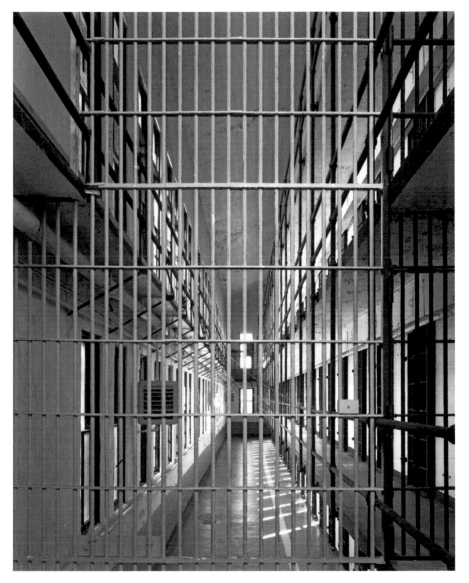

At night, the empty 1912 cellblock is never quiet. *J.M. Cooper photograph.*

The prison is scary enough during the daytime, but at night, it becomes a terrifying place. To spend a night wandering the grounds in the dark is not for the faint of heart. Shadows follow in your footsteps. Unseen eyes seem to watch your every move. You constantly look over your shoulder into the darkness.

There were murders, riots and two legal executions in the prison. George Rock and W.A. Hayes attempted an escape in 1908. They killed the deputy warden and stabbed Warden Frank Conley. It took more than one hundred stitches to sew him back together. Warden Conley shot both Rock and Hayes during the deadly scuffle. But the bullets were faulty, and neither man died of his wounds. Conley nursed each man back to health so he could carry out their sentences inside the walls as an example to others who tried to escape. Both Rock and Hayes were executed by hanging in the prison yard.

Another violent event in 1959 brought Montana national publicity. Hardened con boss Jerry Myles; his nineteen-year-old boyfriend, Lee Smart; and George Alton staged a riot. Brandishing mops soaked in flammable liquid, they took eighteen employees and five fellow inmates hostage. Deputy Warden Ted Rothe was killed. As the town held its collective breath in horror, the National Guard, armed with World War II bazookas, machine guns and tear gas, stormed the prison. Bazooka scars still mar some of the bricks of the 1912 cell house where Myles and Smart holed up in its northwest tower. In the end, according to their death certificates, Smart shot Myles and then killed himself.[18]

Ghost hunters find great supernatural activity in the historic prison. Many professional groups have conducted paranormal investigations there, including West Coast Ghost Hunters of Oregon, Tortured Souls Investigations of Missoula and Friends of Ghosts (FOG) of Seattle, Washington. They have spent nights photographing and recording electronic voice phenomena, or EVPs. The naked ear cannot always hear leftover voices and sounds from the past, but tape recorders can sometimes pick up them. Many have recorded cell doors slamming and heavy footsteps in the 1912 cell house. Residual, or leftover, noises from the past like these are not the only activities investigators sometimes capture. They strive to record active spirits, too. So they ask questions as they go along. Occasionally, they get lucky. Spirit voices, images and other things sometimes manifest.

In the summer of 2005, photographer J.M. Cooper and I were beginning a book project on the history of the prison. Cooper decided to photograph some of the interior spaces of the 1912 cell house. My daughter, Katie, home from college for the summer, had agreed to serve as Cooper's photographic

assistant. The two decided to photograph the isolation cells that sit a partial level down from the main tier of cells. A flight of concrete steps leads to the area where several heavily fortified cells accommodated unruly prisoners. It was a difficult area to photograph as the space was tight. Cooper directed Katie to set up his tripod underneath the cement stairway. Cooper was checking out the short row of cells as she fiddled with the tripod.

It was a hot, humid day, and Katie was wearing a loose summer shirt. As she bent over to make adjustments, she felt a hand slide under her shirt and up her bare back. Straightening up with a start, she whirled around. No one was there. The incident was very disturbing and difficult to shake. She later shared what had happened with a few other employees in the front office. They were not surprised and assured her that she was not alone. Others had experienced identical incidents in that same area.

I witnessed a frightening event on a very cold night in April 2008. While I do not make a practice of paranormal investigation, as a historian I am sometimes invited because of my background knowledge. At the time, my book on the history of the prison had just been published and so Friends of Ghosts (FOG) invited me to spend a night with them as they investigated the museum complex. The team of five included two women and three men. There were also several museum staff, the editor of the *Deer Lodge Silver State Post* and me.

There is no heat in the prison complex, and the cell block was so cold that no digital temperature readings could be taken. The three male team members set up a recorder in one of the end cells on the second tier. As they crowded into the end cell, one of the men—Russ—suddenly felt compelled to get out. Before he could step through the cell door, he felt something grab him and slam him into the wall. The impact was so violent that the back of his jacket was covered in plaster.

There were several of us in the museum headquarters when the three men came in. Even though all were visibly upset as they told us what had happened, all three were determined to return to the cell. Russ in particular wanted to confront whatever it was to determine why he had been the target. I went with them.

Once again in the cell, investigators asked a series of questions, instructing the "spirit," or whatever it was, to respond with one tap for a "yes" answer. I was present and heard Russ ask the questions and the single taps in response.

"Were you a guard?" *Tap.*

"Do you know me?" *Tap.*

"Was I an inmate here?" *Tap.*

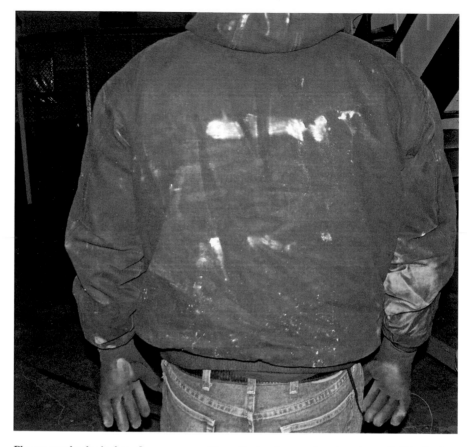

Plaster marks the jacket of a paranormal investigator slammed against the wall. *Friends of Ghosts (FOG)*.

"Are you filled with anger?" *Tap.*

"Do you understand you are dead?" No response.

Through an extended "conversation" that lasted maybe five minutes, it became clear that the entity was an angry guard who had mistaken Russ for a former inmate. When analyzing the tape several days later, the incident and tappings were clearly recorded, including the sounds of Russ being slammed against the wall. Right afterward, the recorder captured an angry male voice that clearly and gruffly called out, "APPROACH!" Guards, apparently, were sometimes as angry as their prisoners.

The next year, in 2009, FOG investigators returned to again set up their recorders in that same second-tier cell. EVPs are often garbled, but in this case, on the tape recorded in that same end cell, a voice left a terrifying

message. The tape captured a very clear, very deep and very angry male voice saying, "GET OUT!"

Ghost hunters have recorded spirits in the women's prison, too. The first several women who did time at Deer Lodge were housed in makeshift quarters within the men's enclosure. Upon statehood in 1889, the prison fell under state control, but still female prisoners shared spaces within the walls of the men's prison. In 1908, prison officials built a separate women's facility just outside the main wall, but even so, the women had to reach their quarters through the men's yard. Women were housed in this building until 1959.[19]

There were never very many women in prison at one time, but their stories are appalling. Lucy Cornforth's is one of the worst. In 1929, Lucy was a single mother living in Miles City with her eight-year-old daughter, Mary. Lucy worked as a meter reader, and she was lucky to have a job, though it paid little. She had problems with her neighbors; she was depressed and came to the conclusion that Mary would be better off without her. She decided to take her own life. She bought some poison, mixed it in a cup with some water and told Mary that she was going to drink it. Lucy, however, changed her mind and set the cup aside. Mary seized the cup and drank the poison, telling her mother that she wanted to go with her, that she wanted to die, too. Within some fifteen minutes, Mary died a terrible death.

Lucy first pleaded not guilty to poisoning her daughter. She did not make Mary drink the poison. Lucy was only guilty of setting it on the counter. Mary knew what was in the cup, and Lucy could not be responsible for Mary's tragic act. As the trial began, however, Lucy changed her plea to guilty. Her lawyer argued that Lucy was mentally disabled, what the newspapers termed a "starred personality." She did not completely understand what had happened.

Lucy, however, knew that her beautiful daughter was dead. Was it really murder or a horrifying accident? The jury found her guilty of premeditated, first-degree murder, and the judge sentenced her to life in prison without the possibility of parole or pardon. There were no social services at that time to help Lucy. Whether or not she deserved it, Lucy Cornforth went to prison at Deer Lodge. Lucy's brother, a minister, disowned her and never spoke to her again. She had no other family or friends to keep track of her.

Lucy accepted her punishment. After fifteen years, a prison official wrote to the parole board that Lucy was a model prisoner and ready for parole. An attorney came forward and agreed to sponsor her, take her into his home and give her a job. But the judge who sentenced her would not agree.

In 1954, twenty-five years after Lucy Cornforth went to Deer Lodge, a retired teacher from Butte wrote to the parole board complaining that Lucy had not received proper medical attention. Her teeth were rotting, and she desperately needed to see a dentist. The teacher asked for a review of the case. The parole board answered that Lucy was so used to prison that she could not survive outside. No one else spoke up for her. Records indicate that Lucy was back and forth between the prison and the state mental hospital at Warm Springs, but neither death certificate nor burial record has come to light.

Lucy Cornforth's case is one example of the awful justice of the early criminal system. If Lucy went to court today, she might have gotten help. The outcome could have been very different. Lucy lived out her sad life alone.

Four months after the 1959 riot, earthquakes destroyed the 1896 cell house, prompting changes. Officials moved the women outside the walls for the first time to quarters across Main Street. The women's facility became twenty-four high-security and disciplinary cells for the worst, most dangerous inmates. Two of these cells for suicidal inmates featured a side bar for handcuffing wrists and ankles to the wall. These changes added another historic layer and violent energy.

During the night I spent with FOG in 2008, we walked through the former women's prison. The air inside was heavy, stale and clammy; the building was very dark. We each took our own directions, and I wandered to the back, where several cells lined the wall. I stopped at the first cell and stuck my head in. I immediately noticed a foul odor. I stepped out into the hall, and it was gone. I called one of the other women over and asked her to step inside the cell. She smelled it, too. It was like old urine and something else underneath, a sickly sweet, rotten stench. We both gagged and stepped into the hallway. A few moments later, we both checked the cell again. The odor was gone.

In addition to the anger and the violence of its maximum-security phase, grief, sadness and loneliness also left impressions on the walls of the women's prison. The energy of such powerful emotions makes the building a perfect place for "residual" haunting. Feelings, voices, smells and even images from the past sometimes manifest. There might also be active spirits there, as some have discovered.

One night, a group of investigators spent a long time in the women's prison. They took several hours' worth of tape recordings. When they later listened to the tapes, there were two stunning responses. When the investigator asked, "Is anyone there?," the tape caught a chilling answer.

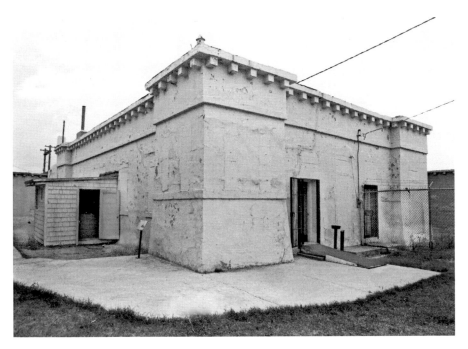

Paranormal activity is frequent in the former women's prison. *J.M. Cooper photograph.*

A woman's voice clearly said, "You can't see me." Sometimes, playing the tapes in reverse brings eerie responses. In this case, reversing the tape, the investigator could hear the same woman's voice. She clearly said, "I am right behind you!"

The prison is one of several museums within the Powell County Museum complex. The Montana Auto Museum is adjacent to the prison, connected through the Old Prison Museum gift shop and offices. Investigators usually include the auto museum in their search for paranormal activity. The collection includes 150 cars from Model As to Mustangs. Many people sat behind the wheels or were passengers in the vehicles. Imagine the varied energies they might hold within their metal shells. Museum employees claim to have experienced paranormal activity there. At least one employee believes the spirit of a child frequents the nooks and crannies among the rows of silent, parked automobiles. Certainly many of the vehicles carried children. Families vacationed in them, and who knows what adventures, or misadventures, befell those long-ago travelers.

I can testify to one eerie piece of evidence that suggests the sprits of children—or, at the least, their residual energies—linger in the dark after hours. In 2009, FOG investigators captured an incredibly creepy EVP among

the empty vehicles. The tape recorder, left alone and running, revealed a faint, young voice. The refrain is enough to give you the cold, hard creeps. A plaintive little voice sings one troubling line: "Ring around the rosy…"

Angry guards, thousands of inmates who did time at Deer Lodge, spirits attached to vehicles in the Montana Auto Museum—all left parts of themselves behind. Residual energy and active spirits are everywhere. The past comes to life in the night, in the dark, in the shadows where the ghosts wait.

6

THE HAUNTING OF THE
JUDITH RIVER RANGER STATION

Thirteen scenic miles south of Utica, adjacent to the swift-flowing Middle Fork of the Judith River, the historic Judith River Ranger Station nestles in a remote meadow in the Little Belt Mountains. The Forest Service has carefully and accurately restored and furnished this early 1900s landmark, which is listed in the National Register of Historic Places. Visitors who spend a night in the homey retreat will not soon forget it. In its comfortable rooms and shadowed corners, in the deepest dark of the night, spirits of the past pierce the dreams of the living and merge with the present.

The beautiful Judith Basin country in central Montana, the true heart of the Last Best Place, surrounds the ranger station. The area offers sweeping panoramas of purple, snowcapped mountain ranges and endless expanses of grass and wheat. It has a richly layered history, too. In the dim past, its lush grass drew vast buffalo herds and other game that brought Indian hunters to the area. Just below the ranger station, a well-worn trail along the riverbank leads to a rock shelter. There, prehistoric travelers stopped to paint images on the rock walls. In May 1805, Captain Meriwether Lewis gave the Judith River its present name, in honor of his fiancée, Julia (Judith) Hancock.

Sixteen-year-old tenderfoot Charlie Russell arrived in the Judith Basin from his home in St. Louis in 1880 to work as a sheepherder for a family friend. Around this same time, ranchers began to move cattle into the basin, adding an important layer to the area's history. Charlie discovered sheep were not his cup of tea, but he fell in love with Montana. On the cusp of change, he saw the remaining buffalo, prospectors searching for gold,

stagecoaches rolling by and sheep and cattle grazing. Seasoned mountain man Jake Hoover took him in and taught him how to survive the rugged western life. Hoover's cabin, where Charlie spent two years, lies not far from the ranger station, in a field surrounded by a sea of grass. It is a nostalgic reminder of the changes he witnessed and the beautiful basin where this beloved Montana artist found his artistic soul.

Charlie worked for several large open range–ranching operations. He was a wrangler on Louis Stadler and Louis Kauffman's OH ranch during the devastating winter of 1886–87. After the partners asked their manager how the stock fared, Charlie painted *Waiting for a Chinook*, depicting a bone-thin cow with wolves circling nearby. This small, unassuming painting with its powerful message launched Charlie's career as an artist. Many of his later paintings include Square Butte, a geographic feature that dominates the Judith Basin. Charlie's work illustrates his intensely spiritual connection to the area and how he loved the vanishing cowboy life that so profoundly influenced his art.

Placer gold brought miners and yet another historical layer to the basin in 1879. The nearby camp of Yogo Town swelled to 1,500 residents. By 1883,

The ruins of Jake Hoover's cabin survive in the Judith Basin. *Author photo.*

almost everyone was gone as the placer gold in Yogo Gulch dwindled. The town, like so many other gold camps, went bust. A decade later, Jake Hoover and Frank Hobson mined a gold claim in the deserted Yogo Gulch. They had high hopes that the claim would pay out. In a sense, it did. The blue pebbles that settled in the bottom of their sluice boxes were curious. Hoover filled a cigar-box with the tiny cornflower-blue stones and sent them to an assayer. The assayer sent them on to acclaimed New York gemologist Dr. George F. Kunz, who identified the blue stones as very fine natural sapphires.

According to some, *yogo* means "romance" or "sky blue" in the language of the Piegan Blackfeet, who were once a strong presence in the area. But by 1878, its meaning had been lost and this derivation is uncertain. Yogo sapphires are difficult to extract and are no longer mined in the Judith Basin. They are therefore very rare and valuable. According to experts, however, Yogo sapphires are there in the ground, just waiting to be discovered.

Native prehistory, buffalo herds, Lewis and Clark, gold mining, boomtowns, cattle and sheep ranching and sapphires are all part of the rich and varied tapestry of the Judith Basin. Its out-of-the way roads and byways are worth exploring and surely are places where spirits of the past roam.

Ranger Thomas Guy Myers arrived in the Judith Basin in 1906. The newly founded U.S. Forest Service sent Myers to work in what would soon become the Jefferson National Forest. Armed with a pocket-sized *Use Book* of forest regulations, his job was to interpret and administer policies regarding public use of the newly set aside "federal" timber, range, water and mineral resources in the Judith District. In the remote mountain meadow, Meyers found an abandoned sawmill and a ramshackle cabin. These relics of a bygone era were lonely reminders of long-gone occupants and their reliance on natural resources.

According to local lore, a squatter by the name of Dirty Emil built the cabin. Legend has it that he buried a fortune of twenty-dollar gold pieces in a bean pot. Emil's partner supposedly murdered him but never found the buried treasure. According to one account, vigilantes hanged the guilty partner. Locals mostly discount the story of Dirty Emil. There are no Forest Service or county records documenting the cabin's history. Only one recorded illegal hanging took place in the Judith Basin, that of a horse thief hanged at the South Fork of the Judith River in December 1879. However, local legends usually have at least some kernel of truth. Perhaps Emil's ghost still hovers around the clearing, protecting his stash.

Ranger Myers nevertheless took up temporary residence in the primitive cabin and set to work building a proper field office and permanent home.

Spirits surely roam the Judith Basin's historic scenic byways. *Library of Congress.*

He constructed the ranger station using a catalogue-ordered "house kit" supplemented with native logs. He scrounged barbed wire that the sawmill outfit had left behind to reinforce the daubing between the logs. This kept the house snug in cold weather. Completed in 1908, the two-story station's simple square shape and use of recycled materials reflect the Forest Service conservation ethic. A log barn and corrals accommodated the horses and livestock needed for the ranger's self-sufficiency.

Myers met and married second grade teacher Emily McLaury in 1910 and brought his bride home to the station. Together they made their remote quarters warm and inviting. Emily put her own touches on the interior. Bead board walls and sophisticated, elegant wallpaper contrast with the rustic style. Emily went home to Iowa for the birth of a son, Robert, in 1914. Robert grew up at the Judith River station, where the family lived year-round until 1935. The couple then moved to Broward County, Florida, and Robert disappeared from the public record. Even family members do not know what became of him. Emily died in 1943 and Thomas Myers in 1960. After 1935, rangers occupied the station seasonally until 1981.[20]

When Forest Service preservationists began extensive restoration, carpenters made wonderful discoveries, finding pieces of the family's life

everywhere. They found a teaching tool, forgotten beneath a layer of sheetrock, in young Robert's upstairs bedroom: a timeline Emily drew on the wallpaper depicting the Stone Age and ancient Mediterranean history. Ranger Myers, true to the Forest Service ethic, recycled everything. The house kit's shipping crate, stamped with Myers's address, framed the living and dining room doorway; wallpaper samples and opened mail filled in gaps around the windows and doors.

Today the Forest Service maintains the station, which sleeps eight, for overnight or weekly rental. There is propane heat, a 1910s period style kitchen, a living room with an upright piano, and three upstairs bedrooms. Outside, a modern vault toilet is steps away. Guests who cross the threshold trade electricity and running water for a rare opportunity to live as the Myers family did a century ago. The station has a homey ambience where the past and its energies linger. Emily's timeline still sprawls across an upstairs bedroom wall, and visitors can record their adventures in a logbook sitting at the desk where Ranger Myers spent much of his career. All, it seems, have had memorable stays, but a few have had especially close encounters with the past.

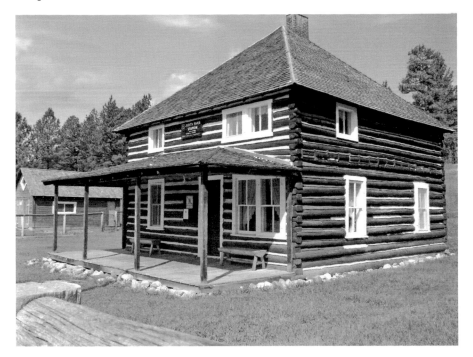

The Judith River Ranger Station is a place where you can feel the past. *Author photo.*

In the summer of 2009, the Judith River Ranger Station served as headquarters for a crew of University of Montana archaeologists excavating at nearby Yogo Town. State historic preservation officer Dr. Mark Baumler, my husband, and our daughter, Katie, an anthropology student, volunteered on the project. They, along with project director Chris Merritt, then a doctoral candidate, took two of the three upstairs bedrooms. The rest of the crew opted to camp nearby.

It was August, and the day had been hot and the work tedious. Katie and Mark shared the largest bedroom as it was cooler and the open windows offered a potential cross draft. All settled in for a good night's sleep. The air was warm, even sticky, and not a breeze stirred as the household became quiet. Darkness spread through the rooms, and moonlight pooled beneath the windows. The hours ticked by.

In the middle of the night, Mark awakened from a deep sleep. Although it was dark, there were sounds of breakfast preparations coming from downstairs in the kitchen. He heard muffled conversation, someone chopping onions or potatoes on the cutting board, pots clanging and bacon sizzling on the stove.

Mark thought to himself, "Wow, that was a short night. It will be light soon, breakfast will be ready and I'll have to get up." But thinking how tired he was, he rolled over and promptly fell back asleep.

Sometime later, he again awakened. It was not yet light but still dark, and the house was very quiet. The air hung heavy and suddenly it occurred to him that with all that activity downstairs, he had not smelled anything cooking. Now that was very odd. He for sure had heard the bacon sizzling on the stove. Why was there no smell? Then he began to worry that someone had gone out to the toilet and left the door open. Or maybe they had left food out and some animal—a bear?—had gotten into the house.

He whispered, "Katie! Wake up. Come downstairs with me. I think there's an animal or something in the kitchen."

"Whaaat?" Katie answered, thinking her dad had lost his mind. "Are you crazy? I'm not going downstairs, especially if there's a bear down there. Just go back to sleep."

Mark couldn't stop worrying, so he grabbed the flashlight and looked at the time. It was 3:30 a.m. He stole out of bed and crept down the narrow stairs to check, afraid of what he might find. He flashed the light all around, but nothing was amiss. The kitchen was in order, and the door was locked. Satisfied that there was no intruder, sure that all the doors were shut and

It was not footsteps on the stairs but the creaking of the rocking chair. *Author photo*.

glad that he still had a few more hours of sleep, he tiptoed back up the stairs, crawled into bed, and promptly fell asleep again.

Katie awakened a while later. She had been uncomfortably warm at bedtime, but now a cloud of cold air seemed to surround her. She shivered and pulled the quilt up to her chin. It was deathly quiet except for her dad's snoring. As she lay there in the dark, she thought she heard something. Listening intently, she heard it again, this time louder. It was a kind of repetitive creaking. She thought maybe Chris had gotten up or someone else was roaming around the house. It was a very insistent, distinctive creaking. Then it occurred to her as she drifted off to sleep again that it sounded like footsteps, and that someone was coming up the stairs.

The next morning, Mark couldn't help thinking about the strange events of the previous night. He asked the crew if anyone had been in the kitchen in the night. All said they had slept quite soundly. He decided not to share his experience.

As the crew sat around chatting, waiting for the real breakfast to be served, someone sat down in the living room rocking chair. Back and forth he rocked, and it creaked loudly. Katie suddenly remembered she had heard that same sound in the night. What she thought were footsteps on the stairs, she now realized was the rhythmic creaking of that rocking chair.

On the way home to Helena, Mark and Katie shared their restless evening experiences with each other. Piecing the events together, they felt they might be somehow connected. Maybe energy stored deep in the layers of the house from all those years—from Robert's childhood, Emily's creative teaching or Ranger Myers' house building—those myriad moments from the past, had converged and caught Katie and her dad in some kind of residual playback.

The Judith Basin has seen its share of high energy. The thrill of the buffalo hunt, the frenzy of the gold rush, action-packed cattle roundups and the rigorous tasks of the early Forest Service—these things have marked the stunning heart of Montana and carry their own threads of electric vitality. The ranger station is just one of the places where the past meets the present.

7

WHEN DREAMS BECOME NIGHTMARES

It was a lovely home, nestled along one of Missoula's wide, tree-lined avenues, in a good neighborhood. It had crisp clapboard siding, a spacious front porch with a swing and a big backyard. Inside, original wainscoting, graceful arched doorways, leaded glass doors and ten-foot ceilings preserved the ambience of the nineteenth century. Lawrence Lyons thought he had found the best house ever, the perfect fit for his family. He was sure his wife would love it.

It was 1968, and Lawrence, a meat cutter by trade, had a new job in Missoula. His family was relocating from Havre. He was just scouting the market and never expected to house hunt without his wife. The opportunity (or was it fate?) just presented itself. From the moment he saw it, the house seemed to lure him, capturing his fancy, and he was hooked.

Lawrence and his wife, Armeda, shared a great passion for antiques, and the house, built around 1890, was their dream. It had three upstairs bedrooms so that the Lyonses' son, Mike, and daughter Deborah could have their own rooms. The downstairs had a formal dining room and a study, each with its own fireplace. He knew the house wouldn't be available for long, so he made the decision and snapped it up before Armeda had even seen it.

Lawrence's enthusiasm was contagious, and the family was very excited to finally move in. Armeda fell in love with the house as Lawrence knew she would. She loved arranging the many antiques that she and her husband had collected in the home's high-ceilinged rooms. It was the perfect setting

E.S. Paxson's Missoula residence and studio, originally on the outskirts of town, was home to the Lyons family. *MHS Photo Archives 944-299.*

to show them off. Among their prize possessions were Armeda's spinning wheel and Lawrence's antique Winchester rifle. He hung it above the fireplace in the study and their collection of vintage wall phones filled other wall spaces. They arranged these treasures around the house along with the family albums Armeda especially cherished. Built-in cupboards in the dining room and study showcased Armeda's spectacular collection of carnival glass. The pieces were her greatest passion, and she had examples of every color imaginable. Both Lawrence and Armeda were thrilled to have a period home with such character and one that fit their tastes so well.

At the time, Mike was in fifth grade, and his sister, Deborah, was a junior in high school. Mike remembers that the house maybe seemed unsettled. But they were excited to move to a new place, and they didn't think anything about it. They loved the house, too, at first. They explored every nook and cranny, except for the basement. That place was dank and dark. It was an unpleasant holdover from times past, with a coal chute and a dirt floor. No one ventured down there but their dad.

Armeda was a registered nurse, and she got a job right away at St. Patrick's Hospital. Throughout the time the family lived in the house, she worked full time. During the first weeks, she worked the day shift, and things were good. The family was thrilled with their new life in Missoula as they settled into their new routines.

The first odd thing about the house began soon after the family moved in. Although built around 1890, the house originally had only one story. Around 1912, the house was remodeled and a second story added. A long dormer with triple windows ran along the front. The addition created a crawl space that ran partially along the front of the second story, accessed from Mike's closet. Armeda heard noises in there, a faint scrabbling or scratching. They thought it was just a squirrel or a mouse. But the sounds got louder, and the entire family was eventually well aware of the scratching. It sounded like a large animal moving around, much larger than a small rodent. Mike was scared of the closet, afraid to get his clothes out in the mornings and so he avoided it whenever he could. The noises gave the entire family the creeps. Armeda always made sure the doors to the crawlspace were shut when the family went to bed at night. But in the morning, the doors would inevitably be standing open. It was as if something had been moving around the house in the night.

Soon, Armeda began to alternate between working the day and night shifts. Mike recalled that this put stress on the family because his mom could not sleep alone in the house during the day. During these times, when the rest of the family was not there and the house should have been quiet, it was just the opposite. There was so much noise when the house was empty it was impossible for Armeda to sleep. As she tried to rest, footsteps in the long hallway outside her bedroom kept her awake. They started softly at one end of the hall and came closer and closer, gaining momentum and becoming louder and louder. The footsteps finally would pass by her closed door, and sometimes, her doorknob would rattle, as if someone were trying to get in. Then the footsteps would fade to the other end of the hallway. It gave her the chills and made her wonder who it was that paced the halls like that. Over and over again, the footsteps would fade out, and then they would start again. There were footsteps in the front room downstairs, too. And then there was the impression on the newly made bed. A few times, Armeda could detect the outline of a body, as if someone had intruded into her room and taken a nap. Clearly there was some restless spirit wandering through the house. It was very disturbing, and she could not sleep. Their mother's exhaustion affected the entire family, but even worse, Armeda was afraid.

The footsteps filled her with an unspeakable dread, and she did not want to be alone in the house.

When Armeda worked the day shift, things were better. There was much less restless activity when the entire family was home at night. The footsteps in the upstairs hallway and downstairs front room were mostly quiet, and the scratching in the crawl space was not so evident. The house was much more comfortable and tranquil when Armeda worked the day shift. It was as if the spirit, or whoever it was that haunted the house, was satisfied to have it to himself during part of the day. As time went on, however, the entire Lyons family experienced paranormal events.

Deborah was a typical teenage girl who liked to spend time in front of the bathroom mirror. That, however, did not last long. Not long after the family had settled in, she emerged from the shower to find the mirror fogged. As she stood at the sink, and the fog cleared, an image appeared in the mirror over her shoulder. She screamed and whirled around, but there was nothing there. She was sure, however, of what she saw, and it was not the only time it happened. Images would appear behind her, staring at her, often. They were traumatizing and eerie and weird, and Deborah began to share her mother's fear of the house. She felt that whoever, or whatever, was in the bathroom, the entity or entities constantly watched her even when she could not see them. After the first time, she hated taking showers and only wanted to get out of there as quickly as she could. The thought made her hair stand on end. Mike vividly recalls his sister's descriptions of these mirror images that intruded on her privacy. Her descriptions terrified them both.

The family dog, a miniature greyhound named Patches, hated the house from the very beginning. She refused to cross the threshold into the master bedroom. Hour after hour, she sat at one end of the long hallway staring at something at the other end. She did the same in the study downstairs. Once, when the entire family was in the kitchen and Patches had taken up her usual place, staring at nothing in the study, a man's loud voice came from that direction. They all heard what he said.

"Bad dog! Bad dog!" yelled the angry, disembodied voice. No wonder the dog hated the house.

Over time, the family encountered at least one of the spirits that inhabited the house. Mike's parents and sister several times saw a full-body apparition, leaning against the kitchen counter. It was a man wearing a vintage cowboy hat and sporting a full goatee. He didn't seem to notice anyone around him. He became fairly familiar and appeared to Deborah and her parents several

times. It was startling to walk into the kitchen and see him there. Always after a few minutes, he would just disappear.

Mike heard his parents and sister discussing the cowboy ghost and their sightings of him. He grew increasingly apprehensive. He knew that his turn would come, he just didn't know when it would happen. He was worried and fearful. The anticipation was hard for a kid, and he thought about it a lot, wondering when he would also see the ghost. He did not have long to wait.

Paranormal events like these are always random and catch us when we least expect them. So it was with Mike. Strolling into the study one day, for once he was not thinking at all about the cowboy. The study always gave Mike a good feeling. It was his favorite room. It made him feel good to imagine the men of previous families, gathering there, probably smoking cigars and enjoying one another's company. He was thinking these thoughts when he stopped dead, frozen in mid-step. There he was! The man was wearing a cowboy hat—not the kind we wear today, but with a pinched crown like ranger's hat—sitting on the floor with his back against the wall, relaxed, right next to the fireplace. He was kind of translucent. After a few moments, he faded away. It was terrifying to know that this ghost was in the house and to never know when he might appear.

In time, the Lyons family moved out, and others moved in. But the house left an indelible impression on Mike. He has carried those scary events in his memory to this day. The family never knew the home's history, nor thought to discover who had lived there. Then some years later, Mike came across a photograph of well-known Montana artist Edgar S. Paxson. He was thunderstruck. Immediately, he recognized Paxson as the cowboy ghost in the house. In doing a little research, he discovered that the Paxsons were indeed previous longtime residents.[21]

The beloved Montana artist was the son of Quaker parents. His father was a painter of theatrical scenery. Like his fellow artist Charlie Russell, Paxson came west looking for adventure. He arrived in Montana in 1877 and, like Russell, worked as a wrangler, cow punching, scouting and hunting for his cattlemen bosses. Paxson used his life experiences on the range as subject matter for his art, but he put his own twist on history. He knew and interviewed many of the characters he later depicted, and he carefully painted them as he wanted them to be, not always as they really were. For example, Paxson knew the great Salish chief Charlo. His painting of the Salish exodus from the Bitterroot Valley portrays finely dressed warriors brandishing rifles. In reality, the Salish were a poor and broken people forced out of their homeland.

Paxson settled in Butte in 1880, painting signs and theatrical scenery to support his family. Like Russell, Paxson was entirely self-taught, but he lacked the marketing opportunities and exposure that Russell gained from the determined salesmanship of his wife, Nancy.

In 1898, the Spanish-American War intervened with Paxson's artistic career. He and his seventeen-year-old son, Harry, together volunteered for service. Like many other soldiers, Paxson became very ill with malaria and was discharged early. The ship carrying him back to the United States encountered a typhoon, and a wave slammed Paxson against a spar, causing serious internal injuries, from which he never fully recovered.

Edgar Paxson always wore a vintage cowboy hat and sported a distinctive goatee. *MHS Photo Archives 944-296.*

Despite ill health, Paxson completed his most famous work, *Custer's Last Stand*, in 1899 after his return from the Philippines. The monumental painting is a focal point at the Buffalo Bill Historical Center in Cody, Wyoming. Pollution in Butte, however, began to affect Paxson's artistic career, as there was little natural light and the smog bothered his eyes. Paxson; his wife, Laura; and two of their four children—son Robert and daughter Lelia—moved to Missoula in 1906 and into the house the Lyons family later occupied.

At that time, the home was on the very outskirts of Missoula, adjacent to the outdoor opportunities Paxson loved. He built a log studio in the backyard, and there, driven by his art, he painted every day until the day of his death. He died at St. Patrick's Hospital on November 9, 1919, leaving a magnificent legacy. Paxson created some of his most famous work—including the murals in the Montana State Capitol and the Missoula County Courthouse—right there in Mike's backyard. The discovery was almost overwhelming.

While the Paxsons lived in the house, they suffered at least one family tragedy. Their son Harry, who survived the Spanish-American War with his father, was electrocuted at Ruby, Montana, in 1910 while working on wiring for the Conrey Placer Mining Company's dredges. Harry left a wife and

two small boys. That terrible time certainly brought grief into the Paxson household. Sometimes, energy like that can alter the essence of a place.[22]

One of Harry's boys, William, years later wrote the definitive biography of his grandfather Edgar.[23] In describing how the artist worked, William Paxson talks about the creativity, or inspiration, that fueled the artist. His grandfather called it the "ghost." When the ghost would visit him, he would work furiously until the painting was done. If the ghost left him midway through, he would have to set the work aside. These in-progress paintings Edgar called "hoodoos." He usually had several hoodoos in his studio at any given time. When the ghost returned, he would finish them. Until it did, it is easy to imagine how restless the artist must have been, how he might have paced through the house.

Once in his studio in Butte, Paxson was having trouble painting a "measly yaller dog." He was so frustrated with this dog that he finally painted him out of the picture. Three days later, the ghost came back, and according to William, his grandfather wrote in his journal, "[I] put the cur in in five minutes, so I think he will *stay*." Maybe the shouts of "bad dog" on that one occasion is some spiritual memory connection to the dog that gave Paxson so much trouble.

Although the studio no longer stands, the house was listed in the National Register of Historic Places in 1986. It has since had way more than its fair share of occupants and been on the market numerous times. Perhaps its other residents also experienced the home's oddities.

Armeda Lyons passed away in 1994, but she always carried a deep love for the house even though she never liked living there. She loved it for its character and its period ambience, but she hated sharing it with the unknown occupant. If

Edgar Paxson's *After the Whiteman's Book*, painted in his Missoula studio, hangs in the state capitol. *Oil on canvas 1912, MHS Photo Archives X1912.07.05.*

she had known who that occupant was, it might have made a difference. Paxson was a colorful character with a strong personality and artistic muse, or "ghost." It is reasonable to assume that his residual energy, or perhaps even his spirit, might be tough enough to manifest itself. That, of course, does not necessarily explain all of the paranormal activity. Mike sums up his family's experience, repeating what his mom always said: "Sometimes, your best dreams become nightmares."

8

MYSTERY AT BRUSH LAKE

Brush Lake is an aquamarine jewel surrounded by remote country in the northeastern-most corner of Montana. A mile long and nearly sixty-five feet at its deepest, the crystal clear lake is just two miles west of the North Dakota border and some twenty-five miles from the Canadian line. Established in 2005, it is Montana's fiftieth state park. Ten thousand years ago, receding glaciers exposed a deep depression to form this magical spring-fed treasure. It is a place with gorgeous sunsets, a long and colorful history and more than a little mystery. Like any body of water, Brush Lake can turn treacherous and demands respect.

Sheridan County is a sparsely populated area. Tiny settlements like Antelope, Homestead, Medicine Lake and Westby and turn-of-the-twentieth-century homesteads dot the area. The first Euro-American farmer turned the soil in 1903, and others followed. In 1906, Danish evangelist Emil Ferdinand Madsen established a colony and named it Dagmar after a thirteenth-century Danish queen. The settlement is seven miles west of the Montana–North Dakota line. The Great Northern Railway built a branch line from Bainville in Roosevelt County to Scobey in 1911, opening agricultural shipping opportunities, and more Scandinavian homesteaders followed. Among them were Danish-born immigrants Hans Christian Hansen and his wife, Marie.

The Hansens were married in Wisconsin in 1899 and spent more than a decade in Racine, where Hans was a self-employed milk dealer. By 1912, the family had grown to include five sons and a daughter. Around 1913, the

Unexplained sounds at Brush Lake add to its mysterious history. *Montana State Parks.*

Hansens homesteaded in Sheridan County, Montana, joining many of their Danish countrymen. Perhaps they chose the area because Marie Hansen's sister and brother-in-law, Agnes and Anton Pederson, were farming in Foster County, North Dakota. Hans filed a homestead claim on land that included the beautiful clear-water lake. What a gem he found! He named it Brush Lake for the chokecherry and buffalo berry bushes that grew in profusion along its shores. At the southwest end of the lake, the Hansens built a home and business on pilings that partially extended over the water. They added several barns, a bathhouse and other buildings. In 1914, they opened Brush Lake Summer Resort, catering to local farm families.

There was nothing like Brush Lake in the region. Its beautiful setting and refreshing waters immediately attracted homesteaders and other locals who had no other place to recreate. It was a popular destination for picnics, boating and summer gatherings. The lake's clear water, unlike other nearby "pothole" lakes, never became stagnant and even in the hottest weather was cool and refreshing.

At the height of the 1915 summer season, the Hansens' business was doing very well when a terrible tragedy affected the lives of the entire Hansen family. In the late afternoon of August 21, Hans was showing a new employee how to operate the motorboat. They took the boat out to the middle of the lake, where the motor stalled. After some time, Marie became aware that her husband was stranded. She took a row boat out to rescue him and the employee. As the Hansen children watched from the shore, Hans stepped into the lighter boat, causing it to capsize. Both Marie and Hans were thrown into the water and drowned. In a bizarre twist, according to newspaper reports, the employee had fallen asleep in the stranded motorboat and was unaware of the accident. Locals maintain that the tragedy was alcohol related, which might explain the employee's odd behavior.[24]

After the accident, the Pedersons moved with their own three children to the resort to care for the orphaned children. The Pedersons eventually proved up the homestead on behalf of the Hansen siblings. During the 1920s, the Hansens leased the resort to several tenants who ran the business, relocating it along the southeast shore, to the east of the original site. A dance pavilion, bar and café brought a stream of Model Ts over the unpaved prairie roads, from as far away as seventy-five miles, to the aqua-blue oasis. Locals supplied plenty of homemade beer and gin, and rumrunners smuggling Canadian whiskey added a stop at Brush Lake to their routes. Illegal libations flowed freely at the resort throughout Prohibition. During the 1920s and 1930s, Brush Lake served as a center of social gatherings of all kinds. As Sheridan

Brush Lake, seen here in 1919, was the scene of fiery socialist and communist rallies. *Courtesy of MHS Publications.*

County was a hotbed of socialist and communist activities during this period, Brush Lake Resort often witnessed fiery meetings of the Nonpartisan League and the local Communist Party and even hosted a Communist youth camp in 1932. It was also the scene of further tragedy on July 21, 1929.

Brush Lake, situated in a natural bowl, provides protection from the winds that often sweep the prairie. But on this Sunday afternoon, it was exceptionally windy. Eighteen-year-old Carl Gjesdal of nearby Westby was just learning to swim. His two friends who were teaching him made an unfortunate decision to use the deepest middle portion of the lake for their classroom. The unusual windy conditions created waves that pulled Carl some distance from his companions. He panicked and began flailing. Before his friends could reach him, Carl went under; he did not resurface. It was some days later before searchers recovered his body, another victim of Brush Lake.[25]

William R. "Bill" and Fannie Sperry Steele acquired ownership of the resort in 1930. Fannie was Montana's famous award-wining bronc rider and Wild West performer; her husband was a former rodeo clown. With the repeal of Prohibition in 1933, the famous couple improved the resort. Then Harald and Marie Jensen bought the property in 1945 and ran the business for the next fifteen years. They made many further improvements

to the resort, modernizing the buildings and equipment. There were bathing suits and towels for rent, a bathhouse with many dressing rooms, a baseball diamond and a lovely grove of trees for picnics and gatherings.

The Fourth of July was always the most popular day of the year at Brush Lake. The Jensens hired many extra employees for the big day. Two boats offered rides for a fee around the lake. Big-band orchestras played in both the dance hall and outdoor pavilion. The festivities generally continued until the wee hours of the morning.

The resort was hopping on July 4, 1948, when seven young people, ages nineteen to thirty, foolishly crowded into a metal row boat after dark. The boat, heavily overloaded, capsized, and five of the party drowned. One young man swam to shore; his wife, however, was one of the victims. Searchers discovered the other survivor clinging to the overturned boat. Over the next week, it took three airplanes, 150 men, sixteen boats and divers from Fort Peck to recover the bodies. Brush Lake had now claimed eight lives, and there would be yet one more—or perhaps, one could argue, two more.[26]

During the twelve years that the Jensens operated the resort, they not only hosted the Fourth of July event but also New Year's Eve parties and large three-day 4-H camps from both Montana and North Dakota. In 1957, they sold the resort portion of the lake to a group of Lutheran churches that used it for Bible camps. These owners removed some of the older buildings and constructed new ones; fire destroyed others. After 1984, the resort portion of the lake had a series of owners and tenants while the rest of the lake remained under the Jensens' ownership.

On July 19, 1997, Brush Lake's final tragedy occurred when Brian K. Ronning of Froid fell from the back of Donnie Engelke's boat. Twenty-one-year-old Brian was a high school valedictorian with an associate degree in agri-business, and he was a fine young man; however, he could not swim. Two of the four people remaining in the boat tried unsuccessfully to rescue him, but they had all been drinking and left the scene. This hampered rescue efforts because there were no reliable witnesses who could point to the location of the accident.[27]

Donnie Engelke eventually faced charges for the death. While awaiting trial, Engelke faked his own demise by leaving his boat adrift near Culbertson. Police were suspicious, however. Engelke was also wanted by the U.S. Marshal's Office for violating his probation on a firearms conviction. Canadian police tracked him to his parents' farm in Saskatchewan, where he was hiding out. When authorities arrived to arrest him, Engelke barricaded himself in his bedroom. During negotiations, he turned a shotgun on

himself; this time, he was not faking. Some say Brush Lake indirectly claimed Engelke's life, too.[28]

Brush Lake Resort closed to the public in 2001, and the southern shores remain under private ownership. Today, it is the other half of the lake that welcomes the public. The state park includes 280 acres on the northern part of the lake. Elliott Jensen grew up on the lake and knows its quirks and oddities. His parents, Harald and Marian, who once ran the resort, owned the entire lake. The Jensen family sold the northern two-thirds for the creation of the state park. Elliott has written much of the history of the lake. He notes that its unique qualities attracted Professor Joe Donovan of West Virginia University and a crew of graduate students in the early 1990s. Donovan, along with other geologists, biologists and climatologists, continue to study the various aspects of the lake's environment and its unique properties.[29]

The lake's clear water makes it attractive to professional divers, who come to hone their skills. Elliott also wrote that divers called in for recovery operations made a startling observation. These experienced divers had worked in recovery efforts throughout the world. They wore professional diving gear and weighted belts and walked on the lake's bottom. They claimed that, as they explored the lake floor, they all heard the distinct chirping of

Brush Lake in Sheridan County has seen its share of tragedies. *Montana State Parks.*

sand crabs. The only other place these divers had heard the strange chirping was in the Pacific Ocean. It is also odd that Brush Lake's clear water has never sustained a fish population. It has been stocked, but scientists believe that the fish die off because oxygen levels are too low. Even though fish can't live there, algae, bacteria and insects seem to thrive. Clouds of hatching insects rise over the water after the winter thaw. Prehistoric sediment layers at the bottom of the lake, once part of the sweeping Missouri River Valley, have secrets to be discovered.

Sheridan County planner Doug Smith is a great advocate of Brush Lake and has an interest in its environment, an interest deepened by strange experiences in the spring of 2005. He was at the lake tearing down an abandoned A-frame building, preparing the site for its new role as a state park. It was April or May, and he spent a dozen days or so, off and on, removing the structure. Of these experiences, he wrote:

On more than one occasion I noticed the sound of rushing air over the lake. At times it was like a jet engine flying low up and down the length of the lake over the water, near the lake shore. At other times it sounded like the roar of a distant freeway off across the lake, lasting 10 or 15 minutes or more. When this occurred, the songbirds all stopped singing, then they resumed singing after the sound went away. I probably wouldn't be telling this if I didn't have witnesses. My good friend Kevin Guenther and his stepson Josh were there at least once when this occurred. We scanned the sky for a diving hawk or other explanation for the sound but there was no good rational explanation for the source of the sound. My (weak) rational theory is that the lake is uncommonly deep and shaped somewhat like a cone and maybe there is an amplification of some underwater activity or chemistry.[30]

"Acoustic anomalies" as Doug calls them, are nothing new. In the summer of 2011, people from the United States, Russia, Costa Rica and Australia reported low-pitched humming that scientists could never fully explain. Others have claimed to hear metallic-like industrial noises or sounds like harps or trumpets. There are historic reports of unexplained noises, as well, even here in Montana. As the men of the Lewis and Clark Expedition prepared for the grueling portage around the Great Falls of the Missouri, they remarked on a sound like the discharge of heavy artillery deep within the Rocky Mountains. Captain Meriwether Lewis recorded this phenomenon in his journal, sure that the noise was thunder. But on July 4,

1805, booms again sounded. The sky was perfectly clear, and there were no thunderstorms to explain the noise.

The great booming has never been explained although there has been conjecture. Similar booms have been recorded elsewhere. In the Netherlands and Belgium, they are called *mistpoeffers*, in the Philippines *retumbos* and in other places *fog guns*. In the United States, they have been recorded in Florida, New York, New Hampshire, Connecticut, Georgia, near the coasts and beside lakes, as well as away from water. Explanations for the explosive booms include bubbles of natural gas released in deep water, earthquakes or subterranean gases moving boulders. Historian Joseph Musselman speculates that we don't often hear the sounds today because of noise pollution. Their source, however, continues to baffle scientists. Some believe alien spacecraft are to blame. Says one resident of Moore, Oklahoma, where the sounds have been frequent, "Maybe we don't know everything we know."

Among the most famous unexplained noises are the "Yellowstone whispers" that sometimes whir over Yellowstone and Shoshone Lakes in Yellowstone National Park. Frank Bradley, a geologist with the 1871 Hayden Expedition exploring the Yellowstone area, noted that the men heard an eerie whistling sound over Yellowstone Lake. They could tell that air was moving in gusts above them, but the pine trees gave no evidence of wind. Others say the sound is like metal cables crashing together, ducks in flight or ethereal organ music. The sounds ebb and flow. Travelers have long reported these sounds although incidents seem to have become less frequent since the 1960s. There have been theories to explain this phenomenon, but no official cause has ever been found.

Park historian Lee Whittlesey notes that at least forty people have died in Yellowstone Lake and that it does not easily give up its dead. As many as seventeen bodies have never been recovered. Some believe that the sounds are the spirits of those trapped beneath the dark waters. Whittlesey does not believe in ghosts or spirits, but he admits that Yellowstone Lake has a "paranormal, preternatural, supernatural element to it."

Doug Smith concluded his thoughts on Brush Lake by noting that in Irish folklore, korrigans—water sprites—fly through the air luring their victims to drown. This notion must, Doug reasoned, have some basis, and he surmises the acoustic phenomenon has occurred in Ireland as well. He admitted, "I've jokingly said that Brush Lake could be a portal to the underworld and these spirits are just buzzing around coming and going." But even though Brush Lake has been a popular spot for more than a century, he has never

Left: "Yellowstone whispers" are among the most famous unexplained noises. *"Yellowstone Lake," Prang's American Chromos, 1875, Library of Congress.*

Below: Theodore Kittelson's 1904 painting *Nokken* depicts what was believed to be an omen for drownings. *Author's collection.*

heard anyone mention this phenomenon. He speculates that it may only occur in the spring when there are no visitors. Siren-like korrigans bring to mind the spring hatch at Brush Lake, when clouds of winged insects emerge from the water.

Coincidentally, water figures prominently in Scandinavian folklore, appropriate to the region around Brush Lake since so many Scandinavian immigrants populated Sheridan County. Nokken is a water sprite and shapeshifter that lures his victims with enchanting music and is the harbinger of drowning. His screams sound like a loon's eerie call echoing across the

water. If Nokken screams at a certain spot, so the legend goes, a drowning will occur there.[31]

Although Brush Lake has no unrecovered remains, like Yellowstone Lake it did not always give them up easily. Recovery efforts almost always took several days or more. Today, Brush Lake State Park is still a popular recreation area. The lake's north end is the state park while the south end, where partygoers once danced the night away, is now quietly under private ownership.

9

THE HOMESTEAD

The creek cuts a blue swath through grass grown tall in Liberty County. Majestic old cottonwood trees line the banks, making the homestead an oasis in the middle of the prairie. Tepee rings scattered across the landscape are evidence that this was a resting place known to many generations of travelers. It was a lovely place to settle, or so it seemed.

The remains of an ornate picket fence surround the Victorian house. Its veranda was once inviting, and the house a showplace with fancy wallpapered walls and chandeliers and a kitchen with a screened pantry. Sheep barns to the north and other outbuildings dot the property. One of them held the Trommer post office from 1910 to 1916 and another, the Trommer School. A cistern provided water for the house and garden. A cellar and chicken house partially dug into the bank stayed cool on the hottest summer days. The house faced west, so sitting on the porch at sunset was the best ending to a long day. But the beauty of the house and its scenic panorama does not match its history.

In the late spring of 1967, Nick Schultz was the instigator of an episode that took place at the old homestead. Nick and his good friend Mel Lehman had graduated from Chester High School. As Mel remembers it, the subject that distinguished this property was not part of community conversation. And it was entirely coincidental that the event happened at all. But even after so much time has passed, neither can forget that long-ago night.[32]

It was a Saturday night. Chester's Liberty Theater was showing a movie that neither Nick nor Mel can quite recall. They were walking home—everyone

walked back then—after the seven o'clock show, chatting about this and that. The movie somehow prompted the conversation to turn to haunted places. It was not a subject the boys had talked about, but the topic came up because of the movie they had just seen. Nick told Mel that he had heard threads of stories from his mother's relatives about a certain place that was still in his mom's family.

"Where is it?" asked Mel.

Nick wasn't too sure, but he thought it was somewhere on the family's vast ranch. He thought his uncle Gus Laas could give them permission and directions. So, on the spur of the moment—as boys usually do things—they hatched a plan. They were young and brave—and foolish, too—and thought it would be great fun to camp out in this place that was supposedly haunted.

It was already late when the boys gathered up their sleeping bags, flashlights, some snacks and a .22 rifle for good measure. They piled in the car and drove over to Uncle Gus's place to ask for permission to camp out in the farmhouse. It was around 10:30 p.m. when the boys rolled into the driveway. Although it was a little late, the family was still up and glad to see Nick, and they welcomed the two boys into the kitchen. They sat down at the table and presented their request. Uncle Gus thought for a moment. Then he told the boys that they might be taking on a challenge that was more than they bargained for.

"What do you mean?" they asked.

For the next hour and a half, Uncle Gus told the boys the family tales about the farmhouse. Those tales remain etched in the Laas family's collective memories. The stories originate with German immigrant John Edward "Dutch Ed" Trommer, who came to the United States in the late nineteenth century as a young man of twenty-one. He worked for the Northern Pacific Railroad as the tracks moved across the Northwest in the early 1880s. He ended up in Fort Benton and took a job as a freight boss on the route from Fort Benton to Fort Browning. Dutch Ed met his first wife, Olive Grove, at Fort Browning, where she had come west to teach. The couple homesteaded, each filing claims, and Trommer added acreage whenever he had the opportunity. He became a prominent rancher with some eight thousand head of sheep.

In 1905, Olive was visiting family in Fairfield, Iowa, when she died suddenly after the birth of her fifth child. The Trommers' two sons and three daughters were subsequently raised by Olive's parents in Iowa. Their names and whereabouts have been lost. The Laas daughters recalled that after their parents acquired the Trommer house, they found photographs of

Chester Signal: A telegram reached here Monday night for J. E. Trommer, conveying the sad news of the sudden death of his wife, who was on a visit with her parents at Fairfield, Ia. Mr. Trommer departed on Tuesday morning's train for Fairfield. Mrs. Trommer was about 35 years old and leaves several small children.

Olive Trommer's death devastated her husband and may have sent him on a destructive path. *From the* Fort Benton River Press, *November 29, 1905.*

Olive and her funeral in an upstairs cupboard. Olive was a beautiful woman, and they made up stories about her.

Dutch Ed married again in 1909, this time a widow, Theresa Hall. Theresa and her husband, Charles W. Hall, had homesteaded in the Sweet Grass Hills in 1901. Charles died in 1907, leaving Theresa with a three-year-old daughter, Irma. Ed promised his bride a good home and brought her and her daughter to the beautiful house he had built for his first wife. But Dutch Ed had his demons. According to Irma's reminiscence, he took to drinking and gambling and was abusive to both Irma and her mother. Seven years later, Theresa claimed the good home Ed promised her did not materialize. She left him in 1917, bought the hotel in Lothair and went her own way. Some speculated that Theresa became acquainted with unwanted occupants in the house and chose not to stay.[33]

Uncle Gus explained that many locals had their own stories about old Dutch Ed Trommer. He seemed to always have sheepherders who would stay all winter until spring and then disappear. Ed claimed they just moved on, but speculation was that they met a different fate and that perhaps the well would provide evidence. There was never any proof. Although Ed succeeded at first, bad luck seemed to dog him. Blizzards cost him many sheep in the later 1890s and early 1900s. A devastating storm in 1903, encroaching fences, squatters on the land and droughts brought changes to ranching. These made a tough life even tougher, and not many stayed. But Dutch Ed was as hard as the land.

Dutch Ed Trommer died in 1945. Gus's parents, Lizzie and Nick Laas, bought the Trommer Place from the bank on a foreclosure sale. It was still a beautiful place with a thousand acres of virgin pasture. They lived in the house only briefly and then left it vacant. Lizzie's kids—except for Billie, who was too young—all had stories about hearing footsteps in the empty

Ranchers usually hired seasonal help, but Trommer's hired hands seemed to disappear without any forwarding addresses. *"Counting Sheep," Library of Congress.*

house. Gus told the boys that he himself had heard the footsteps come down the stairs but said he got out of there before the door opened. It was always the same. The footsteps came from upstairs first, and then they would come down the stairs to the door that opened into the kitchen. The door never opened. The footsteps always seemed to retreat back up the stairs. No one was ever brave enough to open the door.

When they were kids, Gus's brother Charlie was the first to hear the phantom footsteps. He never said much about it, only that he had heard what he thought was someone walking around upstairs but dismissed it as his imagination. However, after the brothers were grown and running the family ranch, Charlie had a hired man, Bob Schoonover, who was picking up rock around the Trommer Place. A huge storm blew in from the west, and Bob decided to take cover in the house rather than ride back in the open tractor. The house had no electricity and it was dark. As the storm raged outside, Bob built a fire in the kitchen stove and nodded off to sleep. A noise awakened him. Someone was definitely walking around upstairs. Bob knew there was no one up there, but he had heard the stories about the place being haunted. The footsteps came down the stairs to the door and stopped for a few seconds, and he was sure the door would open. But instead, whoever or

whatever it was turned around and went back up the stairs. Bob took off in the rain, running and slipping in the mud all the way to Charlie's place. He said he never thought of going for the tractor; he just wanted to get the hell out of there. He was soaked, dirty and cold when he got to the bunkhouse. The next morning, he had to relate the story to Charlie to explain why he had left the tractor.

Gus told Mel and Nick that he had recently hired a Native American couple to pick rock at the Trommer Place. Every spring, picking rock so that the fields could be planted without breaking the drills was important work. During the late 1960s, the house was in pretty good shape and still had most of its windows intact. The couple agreed to live there while they did the work. So they moved in and some days went by. Gus hadn't heard from the couple, so he went over to check on them. Their belongings were scattered throughout the house, but there was no sign of anyone. They had obviously left in a big hurry, and Gus never heard from them again.

Nick and Mel listened to Uncle Gus's stories. He was a sober man, said Mel, a man the community respected. If Gus Laas told you something, you had no reason to believe he was making it up. So against this unsettling backdrop with their heads full of the tales, they started out in the dark. It was very late when they parked at the edge of the homestead. Doing a reconnaissance of the property first, they checked the large barn. They found a rope hanging from a beam with a dark puddle of blood beneath it, where something had recently been slaughtered. The boys were not afraid and ventured back out into the night. It was very dark, the moonlight hiding now and again behind storm clouds. It looked like rain. The boys finally stepped inside the house around one-thirty in the morning.

As Uncle Gus had warned them, the personal items hastily left by the previous occupants were strewn around. The downstairs rooms were all connected, making a circle from the living room to the dining room, kitchen, bedroom and back to the living room. A door to the stairway leading to the second story opened into the center of the house. Upstairs, the boys found one large room with a sloping roof. Doors tucked under the eaves led to storage closets. Some of the doors were open, so the boys made a point of shutting them all.

Once again downstairs, Mel chose a spot under a window and spread out his sleeping bag while Nick threw his in the space under the stairs. It was now around two-thirty. They settled in as the wind picked up. Whap! The front door blew open. Nick got up, closed it and then settled back into his sleeping bag. *Whap!* It blew open again. Nick got up and again closed the

door. Then it blew open a third time. They had to do something to keep the door shut, so they found some bricks and rocks outside and carried in several armloads. They piled them up into a huge mound to brace the door and once more settled back into their sleeping bags.

Mel began to hear a strange crackling sound. This went on for a while. Nick wasn't saying anything. Finally, Mel whispered, "Nick, do you hear that crackling?"

"No," Nick answered.

"It sounds like a rat!" Mel sat up in his sleeping bag and shined his flashlight on Nick, who was eating peanuts. The boys had a good laugh, giving each other a hard time. Finally, once again, they settled down to try to sleep.

Neither slept well as several hours passed. In the deep darkness before first light, Mel awakened. He heard something that sounded like somebody upstairs. Nick was also awake. The boys garnered their courage and went upstairs to check. They swept their flashlights over the large room. No one was there, but several of the doors they had carefully shut were standing open.

The boys did a tour of the house and found nothing. The personal belongings scattered around were a bit creepy, and to add to it, it was rainy and the wind was blowing. But the boys were not about to give up. They went back to their makeshift beds and again lay down to try to get some sleep.

Someone came up to the porch. They both heard the footsteps. They thought maybe it was Uncle Gus, coming to check on them. The footsteps stopped. They didn't hear them again, and the boys began to relax. Suddenly, the door burst open, and all the bricks and rocks flew across the floor. Nick grabbed his gun and pointed it at the open door. No one was there.

Mel and Nick were stunned. There was no way the wind could have blown the door open with all those bricks and rocks piled up against it. They checked outside. Nothing was amiss. The boys stood dumbfounded, looking at each other. Both were thinking that they wouldn't get any more sleep, but if they did not last through the night, what would they tell their friends? Nevertheless, they loaded up their stuff and sat in the car for a while. As they talked, Mel looked at the house, its outline distinct. He drew in a breath and interrupted their causal talk.

"Nick, do you see that?"

Nick nodded. He saw it, too: a shape in the upstairs window that looked like a person. Someone was up there, watching them.

The boys were spooked. Each thought to himself, "I think we'll not stay at the Trommer Place any longer."

In retrospect, nearly fifty years later, Mel still wonders what they saw and how the door opened in such a violent manner. Over the years, they have thought maybe it was someone playing a trick on them. But no one knew they were there except Uncle Gus.

Gus's son, Donnie, Lizzie's grandson, is now one of the keepers of the stories. Donnie was born in 1946 and never stayed at the house, but he spent many summer days following the sheep, searching for tepee rings and hunting arrowheads. He recalled that his grandparents lived in the house for only a short while. Lizzie never told any stories about its being haunted, but when asked, she always said that she either wanted to be in the house or away from it. She hated approaching the house after a long day's work because she said it had a cold, unhappy look. Donnie never heard anyone describe the house as a happy place. He remembered that his grandmother was not a superstitious woman and that she would always say, "No, no," when people said the house was haunted. It was like she was afraid it would decrease the property value if it were true.

According to Donnie's written recollections, he would go in and look through the house but never stayed long. He always felt the need to turn around and look, just to be sure he was alone. He and his cousins would eat lunch under the cottonwood trees during sheep-shearing time rather than in the house. It always seemed strange to him until he heard the stories about Dutch Ed and the sheepherders. Were there bodies at the bottom of one of the abandoned wells? Donnie's cousin Trudy Skari wondered the same thing. She remembered that once she was digging in one of the abandoned wells and came across a glove. It reinforced the stories. She says that the Trommer Place was always ten degrees colder and the weather worse than anywhere else in the area. She and her cousins made up endless stories about what could be.

Donnie shared this story:

During the late 1960s or 1970s, we needed some rock picked at the Trommer Place. Now we had broken up the 1000 acres, and for the last ten years had been trying to grow crops on this rock pile. A group of young Native Americans from Browning got the news that we were looking for some hard work to be done and they being strong, young, and in need of money, agreed to take on the task. They decided that since no one had a motorhome or camper that the Trommer house would do nicely for a place to camp out. They all

The Trommer Place was once an elegant home, but now it is fit for only ghosts. *Courtesy Trudy Skari.*

had sleeping bags, gas lanterns, and one huge drum from the Browning High School marching band. I didn't think much about it. I knew one of them must have had an inside track to the music department if they had this drum. I asked what they used if for. They said it kept the bad spirits away and they liked beating it when they sat around and smoked or drank and told stories. Sounded good to me. Well, they had been there four or five days when Saturday night arrived. I'm sure a good time was gonna be had in Chester or somewhere to offset the hard days of picking rock. The weekend passed and I went over to the Trommer Place to see how it was going. As I arrived I noticed that there were no vehicles or people anywhere. I went into the house and there were clothes strewn everywhere and the drum was there too. Nobody was around and I never heard or saw those guys after that. Now why would they leave a perfectly good drum?[84]

I also had the opportunity to visit the Trommer Place late one night in September 2005. Trudy Skari and her daughter graciously agreed to lead

Phil Aaberg, Ramona Jacobson and me along the dirt road to the old homestead. It was pitch dark, and by flashlight, we explored the place. It was sad and maybe unhappy, just as Lizzie Laas used to say. We heard the water in the creek rushing by and could see the outlines of the great cottonwood trees in the dark. We felt no presence there, no ghosts, just nostalgia for the past and the layers of time deposited on this beautiful stretch of Montana prairie. Yet I do believe that on rare occasions, the past intersects with the present. At those times, other energies might be at work there.

10

RESIDUAL ENERGY AT BOULDER HOT SPRINGS

Three miles south of Boulder in Jefferson County, along scenic Highway 69, historic Boulder Hot Springs lies mostly hidden from passing motorists. The view is fleeting from the highway, but the sprawling complex is a magnificent vestige of other passing eras, when people thronged to take to the waters, to dine in splendor and to gamble the night away. The hot springs and the valley have a very long history. The present hotel is only one small blip in a past of many centuries.[35]

For hundreds of years, Montana's native people traveled through this valley. The pure, flowing hot-water springs eased aching bones and offered travelers rest and respite. Legend has it that the first visitors called this area Peace Valley. It was such a beautiful, healing place that all laid down their weapons. Warring groups never battled on this sacred ground. Ownership of land was not a tribal concept, and early sojourners here believed that the land and the waters were for everyone to share.

In the 1860s, prospector James Riley happened on Peace Valley and its healing hot-water springs. He filed a land and water rights claim and built a primitive bathhouse and tavern in 1864. For more than a decade, he operated a small hotel before enlarging it in 1881. In December of that year, the *Butte Weekly Miner* advertised the springs as a first-class hotel along the stage road between Helena and Dillon. Hundreds, claimed the advertisement, could vouch for the effectiveness of its curative waters in treating "chronic dyspepsia, neuralgia, catarrh, erysipelas, urinary and female complaints." It was a popular resort, and Riley began to build a new hotel. The new

accommodations were unfinished when smallpox swept through the Boulder area in 1882. Riley died in quarantine at the pest house along the Boulder River in August 1882.

New owners built a small, more fashionable hotel. Dr. Ira A. Leighton served as the hot springs' resident physician for more than three decades. In 1891, the hotel was remodeled and enlarged in the Queen Anne style and boasted fifty-two rooms, electricity, facilities for invalids, a gymnasium and various entertainments for its guests.

Conveniently located two hours from Helena and Butte along the newly completed Northern Pacific Elkhorn line, the hot springs opened a branch of the Keeley Institute, one of the nation's first medical treatment centers for alcohol, morphine, nicotine and other addictions. Under founder and medical doctor Leslie Keeley, the first center opened in 1879 in Dwight, Illinois. By the 1890s, every state had at least one Keeley Institute. The Keeley Cure offered the first "scientific" remedy for addiction. Although the medical profession never endorsed it, the treatment included injections of what Dr. Keeley claimed was "bichloride," or "double chloride," of gold.

Boulder Hot Springs in the 1890s was an elegant Queen Anne–style therapeutic resort. *Walter H. Weed, Mineral Vein Formation at Boulder Hot Springs, 1900.*

The treatment became known as the "gold cure." The ingredients were secret, and some physicians doubted that bichloride of gold, a poisonous substance, was used at all in the concoction.

Boulder Hot Springs had several owners until 1909, when wealthy Butte banker James A. Murray acquired the property. Between 1910 and 1913, Murray remodeled the older Victorian-era Queen Anne–style building and constructed the present bathhouse, east wing and west addition in concrete, a relatively new and increasingly popular building material. The hotel's capacity more than doubled. The California Mission–style hotel features raised parapets and arches, a domed bell tower and a covering of stucco. The opulent interior included Tiffany-style glass lighting, beamed ceilings and hand-stenciled walls in the Arts and Crafts tradition.

Under many different managers, the history of the hotel is somewhat murky in the 1920s, when Prohibition encouraged clandestine activities to flourish and illegal liquor flowed freely in Montana. Ironically, this is likely true of Boulder Hot Springs, where its clinic once treated alcohol addiction.

Upon James A. Murray's death, ownership of the hot springs fell to his nephew, James E. Murray, in 1933. Elected to the U.S. Senate in 1934 to fill the vacancy left with the death of Thomas J. Walsh, Senator Murray operated the hotel off and on under a series of managers. In 1935, Boulder Hot Springs happened to be in one of its vacant periods when a devastating series of earthquakes left Helena and the Helena Valley reeling.

In a most generous gesture of good will, Senator Murray turned over the hot springs to the Sisters of Charity of Leavenworth at St. Joseph's Orphanage. The campus and children's living quarters out in the Helena Valley had been virtually decimated, leaving more than 100 children homeless. In the several days following the late October temblors, the children had been temporarily cared for in coaches loaned by the Great Northern Railway. No space in Helena was large enough to offer housing for so many children. The sisters felt that providence truly intervened when Senator Murray offered Boulder Hot Springs. The hotel opened its west wing, and 120 children and 3 sisters lived at the hotel for some weeks while the orphanage was rebuilt. After the children moved back to Helena, hotel management had to repair damage to the rooms.[36]

Locals swear that Boulder Hot Springs was a place where prostitution thrived and women did a brisk business. No evidence has come to light to substantiate this claim, but it is possible. Closure of red-light districts in 1917 and at various other times affected most towns, and many women moved into urban rooming houses and hotels. Boulder Hot Springs did

Keeley Institutes opened across the nation offering the first addiction remedy based on science. *From the* Anaconda Standard, *April 14, 1895.*

in fact have periods between managers when the property could have been used for illegal shenanigans. One source claims that during a shutdown by the district attorney in Butte, the women of Butte's red-light district moved to Boulder Hot Springs to rest and wait for things to cool down.

Senator Murray sold the hot springs to C.L. "Pappy" Smith in 1940, and for the next thirty-five years, it was operated as the Diamond S Ranchotel, a dude ranch offering trail rides and campfire cookouts along with hot springs amenities. Around 1960, the Diamond S began offering Saturday night smorgasbords, drawing some four to five hundred hungry locals each week. Between 1960 and 1990, the hot springs became a working cattle ranch for a while, operated as a small hotel under several owners, and the property was eventually subdivided. Although owner Stewart Lewin made substantial repairs and saw the building listed in the National Register of Historic Places, the hot springs closed in 1989.

Today, under a limited partnership, owners have completely renovated the east wing and are working on the restoration of the west wing. They have made many improvements, including tiling the pools and installing a geothermal heating system. The water comes out of the ground at 140 to 175 degrees and is cooled with well water. The water in the indoor pools ranges from 104 to 106 degrees, and the outdoor pool is between 92 to 98 degrees, depending on the time of year. The pools are open year-round. The hotel staff invites individuals and large and small groups to enjoy the historic ambience of this healthy retreat. Architecturally significant as vintage Queen Anne remodeled to a newer style, Boulder Hot Springs is a rare survivor among the many large-scale hot spring retreats that provided health, respite and recreation to early Montanans.[37]

One dark and unforgettable fall evening in 2004, a group of us assembled at Boulder Hot Springs. We gathered in the lobby, around the fireplace where Teddy Roosevelt once sat while on a local hunting trip. The rich woodwork and warm furnishings transported us back to the 1920s or '30s, and it was

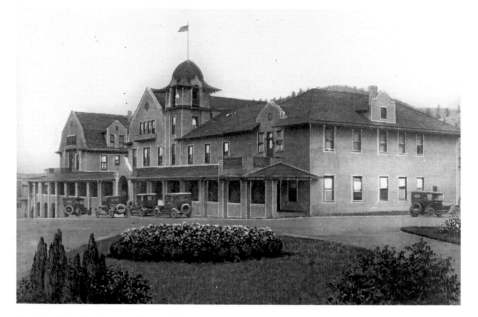

Boulder Hot Springs, a place of high residual energy, appears today much as it was in 1920. *Courtesy Boulder Hot Springs.*

easy to imagine that we were in the midst of another time. Our purpose, however, was not to imagine but to experience, or try to experience, the past.

Patrick Marsolek, a clinical hypnotherapist practicing in Helena and Missoula, had gathered a dozen adults who wanted to hone their intuitive skills. In the days leading up to the seminar, Patrick had provided exercises for the participants to prepare them for the experience and to open their minds to the possibilities of intuition. None of the participants knew the history of the hot springs. That was my job. I was there as a historian familiar with the property's past. The object was to explore a portion of the building, not communicating with one another; gather individual impressions; and then share them with the group. The hope was that I could confirm the participants' impressions by matching them with the history of the hot springs.

Management took us on a brief tour of the facility and then graciously allowed us to explore the upper floors of the closed and long-abandoned west wing. There was neither heat nor electricity, and so we explored mostly by flashlight. For an hour or so, we walked through the long hallways and into each of the former hotel rooms. Although now the two upper floors of the west wing are undergoing restoration, at the time the rooms were in bad

shape. Paint was peeling, and chunks of plaster and debris dotted the floors. Everything smelled old and damp. It was cold, and we wandered around, not speaking with one another, crunching plaster underfoot as we walked.

After roaming the dark corridors and many rooms for an hour or so, we gathered on the wide stairway, which led from the west wing to the lobby. Halfway down the stairs was a large landing where we stopped. The idea was for each to share his or her individual impressions. Some of us sat on the stairs, and others sat cross-legged on the landing. Each spoke quietly in turn. Women made up most of the group, but there were also a few men. Each of the men claimed that they felt a seductive female presence. There was one younger guy in the group who, though very embarrassed, admitted that the female kept plucking at his shirt, asking him to stay. Although historically this aspect of Boulder Hot Springs is tenuous, locals do claim that prostitutes once worked in a portion of this wing.

Even more eerie, however, were the impressions of most of the other participants. One by one, as both men and women stood up and shared their experiences, most expressed confusion. Patrick encouraged them to trust their feelings. Some said that they heard children's laughter. Others heard children running in the corridors. Still others thought there were balls bouncing down the hallways. Some seemed to have experienced one of these events, others a combination of or, in some cases, all three. None of the students knew that after the destructive Helena earthquakes in 1935, 120 orphaned children spent weeks in the west wing.

Finally, one last participant remained to share her experience. She had curled up comfortably in a corner of the landing. She unfolded her legs, stood up and gave a great stretch. It seemed a little odd.

She said, "This is the strangest thing. I feel just like a cat and I need to stretch." Manager Barb Reiter was with us on the landing. I heard her suddenly suck in her breath. She looked incredulously at the woman.

"Oh my goodness," she exclaimed. "You were curled up in the exact spot where our elderly resident cat, Cleo, loved to nap. Just last week, he passed away peacefully, right there—the spot where you were sitting."

11

STORMIT BUTTE

A butte in South Central Montana's Carbon County is named after J.P. Stormit, a colorful, old-time cowboy. Stormit Butte is a prominent local landmark in the rolling ranchlands between Boyd and Joliet. No one knows where he came from or when he took up local residence in Carbon County. The 1880 Montana census records a fifty-year-old man of similar name— John Storment—who was born in Illinois. In 1880, he was tending horses for Levi Sterling in Meagher County's Missouri River Valley. It is likely that this is the same person. Census takers sometimes spell names incorrectly, or phonetically, and sometimes names have a way of morphing.

Old man Stormit, or "Stormy" as some locals call him, was a mysterious, eccentric character. He had a shack that sat above Cherry Springs, four miles south of the butte that today bears his name. Old man Stormit watched over a herd of horses he brought to graze below the butte. He spent his days camped out on the high bluff watching over them. According to Nellie Israel of Joliet, Stormit took care of the horses that belonged to the coal mining company at Carbonado. Others say the horses were Thoroughbreds he acquired from Marcus Daly's Bitterroot Stock Farm. Still others believe that they were a wild herd Stormit claimed during open range–grazing practices before the days of homesteading.

All agree, however, that Stormit was very protective of these horses under his charge. He spent his days hunched down over the edge of the butte above the sweeping view that stretched for miles, keeping constant watch for rustlers. Old man Stormit loved those horses with a fierceness that matched

John P. Stormit watched for rustlers atop this butte that today bears his name. *Debbie Hronek photograph.*

the glitter in his eyes. His wild eyes looked right through a man, even in the dark. On stormy nights he would be out gathering his herd, riding out the weather with them. Locals could see the distant yellow-orange light of his lantern swaying in the wind.

Old man Stormit was a small man who stood not much more than five feet tall. Rough and unkempt, he sported a four-foot beard, nearly as long as he was tall, that was always stained with tobacco juice. Sometimes, he would braid it and tuck it in his pants. But when he rode the range racing with his herd of horses, his long beard flowed behind him, his fierce eyes glittered and his strange cackling laughter echoed in the wind.

In the 1970s, the Joliet 4-H Club gathered interviews of old-timers who recalled J.P. Stormit. Ray Leverich was twelve when old man Stormit got sick. Stormit sometimes shared a cabin with John Barlow, but when he got sick, he spent his final days at Lew Shank's cabin, a quarter mile east of Carbonado. Leverich's mother sent meals to the two men, and Leverich was the delivery boy. Stormit lay ill in a corner of Shank's cabin, rolled in his quilts or "soogans." The cabin smelled bad and was a scary place for

"Stormy" had a four-foot beard and glittering eyes that looked right through a man. *With permission, History of Carbonado and Boyd.*

a twelve-year-old. Leverich remembered that Stormit's beard was very dirty. "He chewed tobacco night and day," said Leverich. "He died with a big chaw of it in his face."

E.T. Hennebry visited Shank's cabin a few days before Stormit died. He did not get a very good look at him. "It was shadowy in the corner where he lay," he recalled. "Even so, his fierce eyes seemed to glitter through the darkness at me."

Old man Stormit died in 1898. There was no ceremony, no eulogy, no funeral. Ray Leverich's brother, Frank, and Hennebry followed Stormit's final wishes and saw to his burial. They covered him with his soogans and laid him in the ground atop the butte. High on the bluff, a tall wooden cross stands starkly against the sky, marking the grave. But many believe he does not rest in peace. Off and on for more than one hundred years, Stormit's yellow-orange lantern light has sometimes been visible, moving on the butte and in the fields below. It disappears and reappears in a different spot.[38]

Many locals have seen the lantern light. Skeptics claim it is nothing more than swamp gas. While there are springs in the area and swamp gas is known to sometimes give off light, swamp lights stay in one area. This light moves around. Mike Manweiler is one of the reliable local witnesses who knows about the lantern light. He grew up on a ranch in the area and recalls a number of occurrences and people who have seen the floating lantern light. And he has seen it, too.[39]

Over the last century, Mike's grandfather, his father and various others have reported seeing the phenomenon. Some have even shot at the light, but bullets do not faze it. Neighbors working in the fields after dark have also seen the light. Some years back, one of the neighbors was out farming after dark. He was working with a John Deere 1530 tractor that had no lights on it. In order to see what he was doing in the dark, he had a lantern on the fender. As he worked, he saw the floating lantern light off in the distance. It came closer and closer across the field and finally knocked his own lantern right off the tractor. He gave up night farming after that.

Mike recalled that when he was a boy, he; his brother, Robert; and their sister were with their parents on a visit with friends. The friends' ranch sat just below Stormit Butte. The kids were bored with grownup talk, and so while the grownups visited in the house, the kids amused themselves playing hide and seek out back. It was evening, and the sun had set. There was a creek that ran behind the house. Bushes that grew along the banks provided good hiding places. Mike and his brother and sister were heading from the back of the house down to the creek when all three of them saw a figure come out of the bushes. It had no lower half; just the top half was visible. It was a man around five feet tall. And its most distinctive feature was a very long beard. All three saw the same thing. Both Mike and Robert to this day believe they saw the ghost of J.P. Stormit.

Mike had one other experience with the light. He was driving home on Cow Creek Road after visiting his parents' place one night. It was after dark, and as he drove along, a bright light hit the driver's side window. The light was so bright it was almost blinding, and it was hard for him to see the road ahead. He couldn't tell where the light came from. It stayed with him, keeping up with the speed of the car, for at least a mile or a mile and a half. As suddenly as it appeared, it extinguished. There was no rational explanation.

"This is not just one person's imagination," said Mike. "Many people have reported the floating yellow-orange lantern light." He and others who have witnessed it believe the light is from the lantern Stormit carried when he was out looking for his horses. And when a storm gathers, locals attest, old man Stormit's cackle rises on the wind and his thundering herd of ghost horses rumbles across the valley.

12

THE CAPITOL CAMPUS AFTER DARK

The Montana State Capitol Campus Historic District, officially listed in the National Register of Historic Places in February 2016, is a grand expression of Montana's political history and the evolution of the state's judicial, financial and social services.[40] The campus is also a place of highly charged emotion where various battles have been won and lost and where the human cost has sometimes been ultimate. There are colorful stories to tell about the various agencies and buildings within the district's boundaries and the struggles and victories that make up their individual histories. The focus of this story is on two separate incidents in time and how those events have potentially affected the "spiritual" history of the Capitol Campus.

Buildings and places have physical histories, so why would they not have spiritual histories, too? Homesteads, buildings, towns, riverbanks, buttes, lakes or anywhere anything living has passed time has a spiritual history. Energy, especially emotion-charged energy, leaves a footprint. It follows, then, that the higher the emotion, the more indelible and enduring the footprint.

The Montana State Capitol Building is the oldest and most impressive of the state's collective campus resources. The building of the capitol was initially fraught with corruption. The first Capitol Commission, appointed in the 1890s to oversee the design selection and construction, was disbanded in disgrace in 1897, accused of inflating costs and pocketing the excess. State architect John C. Paulsen was the key witness and committed suicide on the eve of his testimony before a grand jury. His testimony would have implicated

him in similar schemes in the construction of other state buildings. Under a new commission, plans went forward. But as the building was under construction, two fatalities marred the project.

The first tragedy occurred around 5:00 p.m. on October 25, 1900. A workman heard something fall in the building as he was leaving for the day. He assumed it was a wheelbarrow that fell from the planking somewhere in the building. An hour later, the night watchman heard cries and discovered U.S. deputy marshal Samuel Jackson lying injured in the basement. He had fallen through the planking from the first floor. Why he had entered the construction zone so late in the day was a mystery. It was already dark, and there was no light in the building and no solid flooring, only planks. He either broke a plank and fell through or lost his balance. Exactly how the accident happened was never determined. Jackson was a very large man and had fallen some twelve to fifteen feet. Getting him out of the basement in the dark was a feat. Finally, working by candlelight, rescuers lowered a wheelbarrow on pulleys and brought Jackson up in that manner. A doctor quickly determined that he could not live long, as he had broken a rib that

The Montana State Capitol is not quiet at night. *Author photo.*

had punctured his lung. He also had a broken leg and head injuries. Jackson was too large to fit in the cab that had been called for him, so he was taken by wagon in the wheelbarrow to St. Peter's Hospital, where he died an hour later. Although he remained conscious throughout, the delays in discovering and getting him out and then transporting him to the hospital proved too much for him to withstand.[41]

Two months later, there was a second fatality. The circumstances were oddly similar. On the afternoon of December 24, Nicholas Kohr, a stone-setter's helper, was working on the inner terrace at the base of the dome. He either forgot the danger or didn't know the plank was loose when he stepped on an unfinished portion of scaffolding. Eyewitnesses said that he was running along the planking and passed another worker who saw that he was about to step onto the unstable scaffolding. The worker caught Kohr's clothing and nearly fell with him. Kohr fell violently headfirst nearly thirty feet. On the way down, he struck a steel beam that crushed his skull, killing him instantly. He was dead before he hit solid flooring.[42]

It is hard to say whether these two horrific deaths explain the odd events in the capitol after hours. Surely the strong political intensity that has filled every nook and cranny of the building since the first legislative session in 1903 has endowed the very walls with an unusual force. And maybe there have been other deaths in the building in more than a century of use. Or perhaps passionate politicians—and Montana has had many of them—return to their offices after death or roam the hallways. Whatever the cause, security guards and cleaning crews who spend time in the capitol after hours claim that they find the lights on in locked offices, unlocked doors suddenly locked and locked doors open. In the deepest hours of the night, the building is not quiet. Footsteps echo in the hallways, and doors slam in the dark.

The capitol is not the only campus building that remains active after state employees have gone for the day, leaving the hallways empty and the offices dark; however, the spirit in another state building is much more specific.

In the early twentieth century, politics and casualties played significant roles in the war against Rocky Mountain spotted fever. The battleground stretched as far away as Africa and Mexico City, but the major skirmishes were fought in Montana's Bitterroot Valley and on the Capitol Campus in Helena. In 1901, the newly created Montana State Board of Health became aware of the disease, sometimes called "black measles," in the Bitterroot Valley, where it had been documented since 1873. The mysterious origin and lack of successful treatment was very troubling. Ten out of fourteen cases in 1901 had ended in death. Symptoms included excruciating pain in

the bones, a dramatic blue-black rash and a fever as high as 106 degrees. At the time, most doctors thought drinking melted snow in the spring caused the disease. Others believed the sawdust piles at Marcus Daly's lumber mill or spring winds blowing over decaying vegetation were to blame. As the Bitterroot Valley stood on the brink of the "apple boom," there were economic reasons to pursue the study of spotted fever. No one wanted to settle on land and live in constant fear of this disease.[43]

In 1906, Dr. H.T. Ricketts induced spotted fever in a laboratory animal, proving that ticks transmitted the disease. He developed a preventative serum. Unfortunately, it had to be administered within three days of the tick bite, but symptoms did not usually appear that soon. Entomologists and biologists (one of whom was Clarence Birdseye, later famous as the inventor of Birds Eye frozen foods) pioneered extremely hazardous research in a remote, tick-infested log cabin southwest of Florence, Montana.

In 1912, Dr. William F. Cogswell became executive secretary of the Montana State Board of Health. He took up curing spotted fever as his cause and had a difficult road. Governor Edwin Norris wanted no publicity about the disease or ongoing research. He and others feared adverse effects on real estate values and homesteading in the Bitterroot Valley.

The legislature created the State Board of Entomology in 1913, with Dr. Cogswell as chairman. The number of spotted fever cases increased, and the Livestock Sanitary Board needed space for laboratory and animal research. The Livestock Building at the southeast corner of the capitol grounds was completed in 1918. Originally, it included cages and research animals in the basement and laboratories and offices on the upper floors. In 1919, a casualty there reminded everyone of the hazards of spotted fever. Dr. Arthur McCray, state bacteriologist, was injecting guinea pigs with spotted fever in the Livestock Building laboratory. He became infected through a scratch on his hand and subsequently died.

In 1921, state senator Tyler Warden of Lolo and his wife both died of spotted fever, bringing Montana national publicity. The state legislature approved only $9,600 of the requested $22,500 to create a spotted fever research center. Thanks to Dr. Cogswell's efforts, the U.S. Public Health Service took over the funding. Converting a schoolhouse west of Hamilton into a research facility, Drs. R.R. Spencer and R.R. Parker developed an effective spotted fever vaccine in 1924. Unwilling to lose precious time testing animals, Dr. Spencer administered the first dose to himself.

Vaccine preparation required large-scale rearing of infected ticks. By this time, spotted fever was widely recognized, and there was not enough room

Experiments in the Livestock Building laboratory caused the death of the state bacteriologist in 1919. *Courtesy SHPO.*

to handle the demand for the vaccine. In addition, working conditions in the old schoolhouse were hazardous. Eleven of the sixteen employees became ill over a period of five years, and one other researcher died.

Partly due to Dr. Cogswell's untiring advocacy, the 1927 Montana State Legislature authorized $60,000 to build the Rocky Mountain Laboratory in Hamilton for the study and control of spotted fever. The Rocky Mountain Laboratory was sold to the U.S. Public Health Service in 1931 and continues to research diseases without cures.

Dr. Cogswell died in 1956 at eighty-seven. He was a tireless pioneer in public health and in the war against spotted fever and the first and longtime secretary of the Montana State Board of Health. For these and other contributions, the 1963 Montana legislature mandated that the State Laboratory Building on the Capitol Campus, built in 1954, be named the W.F. Cogswell Building in his honor.[44]

Some years ago Ken Walton, a building maintenance supervisor for the Capitol Complex, shared some of the after-hours experiences of night

employees with me. We discussed the slamming doors, the footsteps and the mysterious office lights in the capitol. We also discussed the occasional daytime appearance of a woman in the Cogswell Building. Several employees had seen her wearing a familiar yellow-flowered dress. They recognized her as a former co-worker who was the victim of murder in 1983. Her husband was convicted of the crime. But this was not all.

Ken also told me that a security guard was making his rounds in the Cogswell basement one night, coming down the hall. He saw a figure down at the end, striding toward him matter-of-factly. The guard called out to him, but there was no answer. The man kept coming. He looked a little old fashioned, dressed in a business suit and distinctive bow tie. He came closer and closer and then walked right through the guard, who turned around to find no one there. Security searched the building, but they found no one. The same guard later noticed a portrait of Dr. Cogswell wearing a bow tie; the image matched the man he saw in the hallway.

Joe Fisher, a night security guard on the Capitol Campus in the spring of 2000, also encountered Dr. Cogswell. Joe told me that his duties included nightly rounds through the empty buildings. Around 3:00 a.m. one morning, he was on the third floor of the Cogswell Building. The exits provided some light, but he had his flashlight on as he came down a hallway. He saw a guy standing at the end, about thirty feet away. There was light behind him, clearly illuminating his features. He was rather short, in his mid-forties and

More than one spirit roams the halls of the W.F. Cogswell Building. *SHPO.*

had dark salt-and-pepper hair combed to the side. He wore round, wire-rimmed glasses. He did not wear a bow tie, but his brown wool suit was cut in an older style. He stood with his right hand out, as if he were holding a pocket watch. His coat was open, and his left hand was in his vest pocket. He was looking in Joe's direction but seemed to look right through him, as if Joe was not there at all. The man was there for a few seconds, long enough for Joe to note his features and clothing, and then he was gone. Joe took off in the other direction, bolted down the stars, taking the landings in a single leap. He told no one about the encounter for several months. And he rarely went back in the building after that.[45]

William F. Cogswell was a key figure in the war against Rocky Mountain spotted fever. *MHS Research Center.*

Footsteps in the vast state capitol and late-night visitors in the Cogswell Building are surely not the only after-hours activities in buildings of the Capitol Campus. As time passes, more of these incidents are bound to emerge. All the campus buildings are energy powerhouses, where politics have played out and hundreds of employees have put forth their best efforts. That much power fills the historic district with a rich potential for paranormal activity.

13

AN ECLECTIC EPILOGUE

Driving Montana's hi-line along U.S. Route 2 can be a spiritual experience. There are two special places that always beckon me to stop. One is the Sleeping Buffalo Rock, and the other is the Sacred Heart Church and Cemetery, sometimes known as the "pink church." Jesuit priests established the mission, perhaps the last in Montana, on the Fort Belknap Indian Reservation around 1917. The cemetery opened in 1924. The church is visible from quite a distance, perched on a gentle hilltop. It is an impressive landmark. The cemetery sprawls without order across the hill. Offerings and remembrances decorate some eighty graves. A basketball, a hair ribbon, a tennis shoe, a lariat, a doll—items that meant something to the person—are placed there to ease the heartache of those left behind. Somehow from the chaos of its randomness, a kind of order emerges.

Locals call it a haunted place, and there are tales. One story has it that before plywood replaced the glass in the church's Gothic windows, kids would visit the locked church at night. They claim to have seen hands and faces, pressed against the inside of the glass, souls locked in there, trying to get out.

Linda Reeves and her son, Mark, had no such creepy encounter, but something odd did occur when they visited. They were on the way to Glasgow. It had been a very rough year. Linda's friend Phyllis had recently passed away, and she felt her loss keenly. The funeral was especially memorable. Linda recalled that it was a nice day—blue sky, no storm clouds. A shadow appeared over Phyllis's grave. White puffy clouds seemed

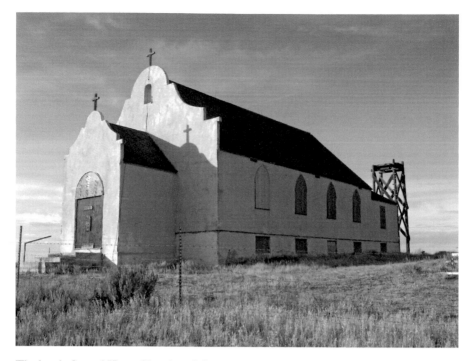

The lonely Sacred Heart Church and Cemetery sit on a windy hillside along U.S. Route 2. *Author photo.*

to materialize, taking the exact shape of a human figure. Phyllis was a very large woman, says Linda, and those clouds took on her exact shape. Photos of the grave confirm it.

On this day, as Linda and Mark drove across the hi-line and pointed their car up the steep gravel drive to the Sacred Heart Church, Linda had Phyllis on her mind. They got out of the car and wandered through the cemetery. As they walked, something caught Linda's eye. She reached down to pick it up. It was a vintage Bakelite pin, with a silver streak through the cursive letters that spelled out *P-h-y-l-l-i-s*. Linda had never seen a pin like that, and she has never seen another. It seemed as if her friend was right there with her.[46]

Hotels, schools, prisons, hospitals and such places where so many people have come and gone and left their energy behind usually make it impossible to identify whose spirit might provide residual hauntings. However, sometimes the events are so specific that identification can actually be made. There is a great example in a senior care facility in Billings where the identity of its resident spirit is no mystery. The center was built on the grounds of a

historic school, retaining the landscaping of the schoolyard. The modern building is a U shape, built around an inner courtyard so that the residents' windows look to the enclosed outdoors.

A few years ago, former supervisor Colleen Benjamin had a special bond with one rather difficult resident. Evelyn (not her real name) had had a hard life, and she herself had never been cared for. Rather, Evelyn was the caregiver of a special needs brother and then a special needs son. When she was diagnosed with Alzheimer's, Evelyn became a patient at the center. It was a role that was very difficult for her to accept.

Evelyn became a familiar figure around the halls of the center. Her looks were distinctive. She had long white hair and rather forward-set eyes and always wore a long duster-like bathrobe. She also had a very strong personality and liked to do tricks. Colleen recalls that her best trick was rolling quarters. Evelyn could make them roll on their edges all the way down the long corridors.

One day, out of the blue Evelyn said, "My family wants me to come home."

Staff told her that her daughter would come to visit her soon. But that is not what Evelyn meant. "No not that family," she said emphatically.

Evelyn's health was good, and so it was a surprise when Colleen's dog Ginger, who spent much time with the residents, began to camp out at her door. This signaled to the staff that the end might be near. Animals often know these things. Recent studies have shown that cats in rest homes often single out dying residents, sleeping next to them. Ginger's instincts were correct. Evelyn quietly passed away about two weeks later. Her room sat empty for a while.

One night, Colleen came in to check on things as she sometimes did. She was standing in the laundry room around 3:00 a.m. No one else was up. She looked across the courtyard and saw that the light in Evelyn's room was on. She went to turn it off. There was no reason for it to be on like that. When she came back into the corridor, the hall lights went out. Colleen thought it was odd. The lights had never gone out before.

Some weeks later, in the wee hours of the morning, three new employees stood chatting in the laundry room. One of them remarked, "There's someone up. I just saw her pass by the doorway. She has a long white ponytail, kind of protruding eyes, and she's wearing a long duster-type bathrobe."

Other staff, none of whom knew Evelyn in life, began to mention the roaming resident and describe her—they claimed to feel her energy passing like the rush of a cool breeze. Colleen, who had known Evelyn very well, did

not believe it. Then one day, alone in the corridor, she happened to glance up and confronted Evelyn's singular trick. Here came a quarter rolling on its side all the way down the hallway.[47]

There are many ways to experience the supernatural. People sometimes have odd, random encounters that seem to make no sense at all. Others have ready explanations. Lee Cook and Ann Dooling had two very different experiences, but each recalls vividly the exact details.

Tom Dooling bought a beautiful Victorian-era house in Dillon in the 1970s to serve as his law office. Tom knew the owner, a nice widow whose recently deceased husband had been well known as a very grumpy man. The former owners had lived on the first floor and rented the second floor to tenants. A pair of French doors off the entryway led to the owners' apartment while there was a stairway up to the second-floor. Visitors looking for the upstairs tenants invariably came into the entryway and knocked on the owners' French doors. This happened over and over, and it enraged the grumpy husband. He put newspapers over the glass so no one could see in, and every time he heard a knock, he would race to answer in an angry frenzy. The last straw came when one day, he raced to answer a knock and suffered a fatal heart attack.

Tom moved in and located his office on the first floor. He and his wife, Ann, removed the French doors and put a chair in half the doorway. From the beginning, Ann had the odd feeling that the grumpy husband was still around, taking up space. The proof came one day when Tom was away. Ann was working in the office. She looked up, and there came the former owner, mad as a hornet, striding toward the doorway where the French doors used to be. He ran right through the chair and disappeared. That was the first of many appearances. He never came when Tom was there, and unfortunately for Ann, Tom was gone a lot. The angry owner kept repeating the scene, and Ann was about to go crazy. Finally, a friend suggested that Ann invite someone to come to the house and exorcise the spirit. Ann took that suggestion. An Episcopal priest performed the exorcism, and she never saw the angry homeowner again.

Lee Cook of Helena describes himself as a pragmatist, not a true believer in things that go bump in the night. He is sure that there is always a rational explanation. But something happened over Valentine's Day weekend 2016 that made him question his convictions.

Lee and his wife were staying at Glacier National Park's Belton Chalet in Room 40. Many have written stories about the ghostly goings-on in this National Historic Landmark. Constructed between 1909 and 1913, the

chalet marks the beginning of tourism in the park. Visitors most commonly report a ghostly man in a brown derby, carrying a satchel.[48]

The Cooks had noted a framed newspaper clipping from the *Kalispell Daily Interlake* that hung in the chalet's lobby. Its subject was hauntings in the main lodge, specifically in the basement, but also in Rooms 37 and 39, on the second floor. Room 40 was directly across the hall from 39. Lee only skimmed the article, but he and his wife noticed that both Rooms 37 and 39 had "Do Not Disturb" signs hanging on the doorknobs.

The Cooks turned in about 11:00 p.m. The chalet sits close to the railroad tracks, and at least ten trains passed by that night, some with their whistles blowing. It was not conducive to sleep, and Lee was wakeful. Around 1:30 a.m., an odd feeling came over him. It was not visual, not your typical fog or apparition. Rather, he sensed something, a presence, between his side of the bed and the window. It was not exactly a chill, but more like a thickness in the air, and he could sense movement. Perhaps recalling the newspaper article, Lee at once thought that this might be a ghost. No words were exchanged, but there was communication. Lee wrote:

> *Call it ESP or whatever you like, but I remember thinking, "Are you a good ghost or a bad ghost?" I never heard a voice, but the words came to me just the same: "No good...no evil." My first response was "Do you wish me harm?" and it answered, "No harm....I am here." I wasn't afraid... probably more curious. A couple minutes went by with no conversation, and I then asked, under my breath, "Are you leaving?" The response was "I am here."*[49]

A few minutes later, the heaviness lifted, and the presence was gone. Lee's wife awoke and asked if he had said something. He answered that he didn't think so but asked her if she had felt anything unusual. She said she had not.

"It was the weirdest thing I've ever experienced," said Lee. "I'm a fairly sane person, reasonably intelligent. But I can't explain it."

Lee Cook's odd experience at the Belton Chalet might defy explanation, but he won't deny that it happened. It is easy to doubt until it happens to you.

Missoula's Sentinel High has seen a lot of traffic. Even so, two of its longtime custodians can absolutely identify the ghost that sometimes hangs around the school after hours. Debby Davis and Frank Shepard work 3:30 p.m. to midnight and have both encountered him. Frank saw him first some years ago.

Sentinel High School split from Missoula County High School in 1957, bringing the school newspaper, yearbook, mascot and, apparently, a resident spirit. *Author photo.*

Frank was down in the depths of the building gathering tools. Another staff person, Dennis Nelson, was behind him. Frank saw a figure ahead of him and whispered, "Dennis, can you see him?" Dennis answered, "No."

He was an older man of small stature and thin, kind of scrawny even, with sunken cheeks. He wore striped overalls and a railroad cap. He stood looking at Frank with his arms folded across his chest. As Frank watched, the man turned, walked toward the tunnel that runs underneath the school and disappeared.

Debby saw the same figure twice. The first time, it was around midnight, and she was finishing her shift. As she turned the lights off in the art wing, she saw a man come out of the home economics room. He walked across the hall, looking at her the whole time. He was dressed in striped overalls and a railroad cap. At first, she thought he had a pot belly, but then she realized he had his arms folded, inside the top of his overalls. He was a small, thin man, and Debby thought to herself that he looked like he needed to be fed. He stared at her until he reached the other side of the hall and walked through the closed door into Room 186.

Debby was not afraid. In fact, when she saw him one other time in Corridor A, she spoke to him: "If you are going to show up," she said, "the least you can do is help me."

Neither she nor Frank has seen him since. However, a photo, discovered in the 1939 county high school yearbook *Bitter Root*, fits both Debby's and Frank's physical description of the nighttime visitor. The picture shows the longtime building engineer at Missoula County High School. In the photo, he is wearing striped overalls, a railroad cap and his arms are folded inside his overalls. Research revealed that this employee lost his life in a tragic accident in 1945. He and a co-worker were checking the school's foundation work in a heating tunnel when a cement slab dislodged and fell on him.[50]

It is a mystery why the former county high school employee is haunting Sentinel High School. The county high school split its campus in 1957, and the two locations became separate schools—present-day Hellgate and Sentinel—in 1965. Some of the old county high school furnishings, the *Bitter Root* yearbook, the *Konah* school newspaper and the Spartan mascot moved to Sentinel High School. Perhaps this connection draws him to Sentinel, or perhaps he is just making sure the building is safe.

And finally Helena's most famous haunted building is Grandstreet Theatre, originally the Unitarian Church built in 1901. Unitarians designed their churches to serve the public as theaters and auditoriums. When the church closed in 1933, it became the longtime public library; then in 1976, it became Helena's community theater. It is a wonderful space, with the original proscenium arch and stage beautifully preserved.

Many believe that Clara, wife of minister Stanton Hodgin, haunts the theater. The Stantons came to Helena in 1903, and Clara quickly endeared herself to the community. Her untimely passing from cancer in 1905 at the age of thirty-four left a great hole in the hearts of scores of children. A former kindergarten teacher, Clara had a huge Sunday school and loved to direct her students in dramatic presentations. One of her young students said that her smile could light up a room, just like sunshine.[51]

There might be other spirits at Grandstreet (theaters are notoriously haunted places), but many believe that Clara keeps those other spirits at bay, watching carefully over the children who attend Grandstreet's theater school and summer camps.

In the fall of 2014, I gave two public storytelling sessions onstage at Grandstreet. During one of the performances, as I talked about Clara and invited her to join us, I noticed something on the floor to my right. It was ink-black, opaque and it kept slithering in front of me and then retreating,

Grandstreet Theatre is one of Helena's most famously haunted places. *Ron Armstrong, with permission.*

almost like smoke. I was afraid the audience would notice my distraction. The black thing was very difficult to ignore, but I finally convinced myself that it was just the lights blinding me and recovered my focus.

A number of my psychically intuitive acquaintances were in the audience. When I got home, I logged onto Facebook and was stunned at the ongoing conversations about the evening. Michael Sweet, a friend and gifted physical medium, wrote that a female spirit had passed by him, moved down the left aisle and up the stairs to the stage. He said that she stood listening and watching and then moved across the stage to stand behind me. "She really likes Ellen," wrote Michael. That was a relief. But was this Clara?

Janet Stellmon noticed that things kept catching her attention on stage behind me, and Jennifer Helmbrecht was drawn to a window in the balcony rafters. She kept looking up there and, at one point, was certain she saw a man crawling on the ceiling, spider-like. She wrote that it felt nefarious.

Kate McKenna Lawler reinforced my belief that Clara is a protective entity. "I think Clara protects folks from a guy with an attitude," she wrote. "Clara seemed to be close behind Ellen while that swooshing dark spirit kept streaking by Ellen's right hand side." So I was not the only person who noticed the black thing!

When my stories were finished, I stayed onstage to sign books. As Kate brought me her book to sign, she later noted that Clara was still standing behind me. She wrote that I turned around and looked back as we both perceived the presence. I cannot say that I remember that part, as many people were pressed around me. But I like to think that Clara was there, as she has always been, protecting those who enter her domain.

NOTES

Introduction

1. An overview of Virginia City's history in general is Ellen Baumler's "More Than the Glory: Preserving the Gold Rush and Its Outcome at Virginia City," *Montana: The Magazine of Western History* 49, no. 3.
2. A portion of this story appeared in Ellen Baumler, "Ghostly Visitors," *Distinctly Montana*, Fall 2011.
3. The detailed stories of Sister Irene, Mary Elling and some of Virginia City's other haunted places can be found in Ellen Baumler, *Spirit Tailings* (Helena, MT: MHS Press, 2002).
4. The traditional view of the vigilantes' actions is told in Thomas Dimsdale, *The Vigilantes of Montana* (1866; reprint, Norman: University of Oklahoma, 1953). A modern opposing revisionist view is in R.E. Mather and F.E. Boswell, *Hanging the Sheriff: A Biography of Henry Plummer* (Salt Lake City: University of Utah Press, 1987). The definitive Montana history is Michael Lang et al., *Montana: A History of Two Centuries* (rev. ed., Seattle: University of Washington Press, 1991).

Chapter 1

5. John R. Colombo's *Windigo: An Anthology of Fact and Fantastic Fiction* (Omaha: University of Nebraska, 1982) gives the most complete discussion of this creature.

6. Robert A. Brightman's "The Windigo in the Material World," *Ethnohistory*, Autumn 1988, is a scholarly account of "wendigo psychosis" and includes the Swift Runner case.
7. An article by Ruth Thorning, "What's in a Bitterroot Place Name?" in the 2007 *Discover the Bitterroot Guide*, published by the *Bitterroot Star*, retells the legend of Sleeping/Weeping Child. A different version of Weeping Child is in *Hamilton Western News*, September 19, 1894. Olin D. Wheeler's *The Trail of Lewis and Clark* (New York: G.P. Putnam & Sons, 1926) tells the grisly story of Weeping Child.
8. The most detailed account of the Lloyd Magruder incident can be found in Nathaniel P. Langford's *Vigilante Days and Ways*, first published in 1890 and newly edited by Richard B. Roeder (Helena, MT: American and World Geographic Publishing, 1996).
9. Theodore Roosevelt's story in *The Wilderness Hunter* (reprinted in various editions) is online at http://www.bigfootencounters.com/stories/bauman.htm.

Chapter 2

10. There are many accounts of Colter's Run—which is perhaps more legend than fact—but one concise biography that covers it nicely is George H. Yater's 1991 paper, presented at the meeting of the Lewis and Clark Trail Heritage Foundation, published as a supplement, "Nine Young Men from Kentucky," in *We Proceeded On*, May 1992.
11. The incident of Colter's ghost is recorded in Nolie Mumey's *The Life of Jim Baker 1818–1898: Trapper, Scout, Guide and Indian Fighter* (Denver, CO: World Press, 1931).

Chapter 3

12. There are numerous versions of the murder of Hugh Boyle and the Head Chief–Young Mule story. The most reliable are those of Forest B. Dunning and Carol Bailey, posted on the MilesCity.com History and Genealogy Forum and in *Cheyenne Memories* by Margot Liberty and John Stands in Timber (New Haven, CT: Yale University, 1967), 250–55.
13. Accounts of Robert Ferguson's murder include the *Yellowstone Journal*, May 31, 1890, and the *Helena Independent*, May 31, 1890.

14. Among the many newspaper reports are the *Miles City Daily Yellowstone Journal*, September 11 and 17, 1890, and the *Helena Independent*, September 13, 1890, and January 24, 1891.

15. The ghost story about the Ferguson ranch can be found in the *Billings Gazette*, January 16, 1903, and in the *Rosebud County News*, January 22, 1903.

Chapter 4

16. The best source for the Chinese experience in Montana is Christopher Merritt, "The Coming Man from Canton," PhD diss., University of Montana, 2010, online at http://scholarworks.umt.edu/etd/5/. Robert Swartout, "From Guangdong to the Big Sky: The Chinese Experience in Frontier Montana 1864–1900," in *Montana: A Cultural Medley* (Helena, MT: Farcountry Press, 2015), 94–120, is a classic study. Ellen Baumler, "Forgotten Pioneers: The Chinese in Montana," *Montana: The Magazine of Western History* 65, no. 2: 41–56, tells the story of sojourning Chinese through material culture.

Chapter 5

17. The most comprehensive physical and human history of the Old Montana Prison is Ellen Baumler and J.M. Cooper, *Dark Spaces: Montana's Historic Penitentiary at Deer Lodge* (Albuquerque: University of New Mexico, 2008).

18. *Jerry's Riot: The True Story of Montana's 1959 Prison Disturbance* by Kevin S. Giles (Bradenton, FL: Booklocker.com, Inc., 2005) details events leading up to and during the infamous 1959 riot.

19. The history of women in the prison system, including the case of Lucy Cornforth, is collected in Ellen Baumler, "Justice as an After Thought: Women and the Montana State Prison System," *Montana: The Magazine of Western History* 58, no. 2, 41–59.

Chapter 6

20. The National Register of Historic Places nomination for the Judith River Ranger Station includes the historical background and the station's

building history. Housed at SHPO, 1301 East Lockey, Helena, the National Register files include photographs and structural reports. The Webster, Iowa, *Webster City Tribune*, June 17, 1910, reported in detail the wedding of Emily and Thomas Guy Meyers. Ancetry.com includes a partial family tree, but oddly there is no record of their son, Robert.

Chapter 7

21. The National Register of Historic Places nomination form, housed at SHPO, provides architectural details about the house and the Paxson family's residency there. Biographies of Edgar S. Paxson include Helen Fitzgerald Sanders, *A History of Montana*, 3 vols. (New York: Lewis Historical Publishing Co., 1913), and lengthy obituaries in the *Daily Missoulian*, November 10, 1919, and most Montana newspapers.
22. Harry Paxson's tragic death is reported in the *Anaconda Standard*, January 24, 1910.
23. William E. Paxson's biography of his grandfather, *E.S. Paxson, Frontier Artist* (Boulder, CO: Pruitt Publishing, 1984), provides the best intimate picture of this talented Montana artist.

Chapter 8

24. The *Glasgow Courier* reported the deaths of the Hansens on September 3, 1915; their biographies are included in the county's compiled history by Magnus Aasheim, *Sheridan's Daybreak: A Story of Sheridan County and Its Pioneers* (Great Falls, MT: Blue Print and Letter Co., 1970).
25. The *Havre Daily Promoter*, July 24, 1929, reported Carl Gjesdal's drowning.
26. The July 4 drownings are reported in the North Dakota *Bismarck Tribune* and the *Kalispell Daily Inter Lake* on July 6, 1948.
27. The boating incident is covered in the *Sheridan County News*, July 28, 1997; Brian Ronning's obituary is in the *Sheridan County News*, July 30, 1997.
28. The *Sidney Herald Leader*, August 26, 1998, reported Donnie Engelke's suicide.
29. Andrew McKean's "Northeastern Montana's New Prairie Oasis" discusses the lake as Montana's newest state park in *Montana Outdoors*, September–October 2005. The Montana Historical Society Research Center's vertical file on Brush Lake includes contemporary articles and

two unpublished manuscripts by Elliott Jensen that tell much of the history of the lake.

30. From Doug Smith's written account to the author, December 21, 2015. Used with permission.
31. Numerous articles on recent and historic unexplained noises as well as the folklore and water myths of Scandinavia are readily accessible online.

Chapter 9

32. Mel Lehman's story came together through oral interviews and exchanges with him during February 2016.
33. The biography of John Edward Trommer's second wife, Theresa Hall Trommer, can be found in Liberty County's published history, *Our Heritage: A History of the Communities in Liberty County, Montana* (Aberdeen, SD: North Plains Press, 1976). John "Dutch Ed" Trommer rose to some prominence as a sheep man and is occasionally mentioned in scattered newspaper articles in the early 1900s. His obituary, in the *Liberty County Times,* March 15, 1945, along with census records, provides the few clues about his life. Trommer's stepdaughter, Irma Hall, also left a personal reminiscence about her stepfather and his problems. Over several weeks during February 2016, Trudy Skari shared this document with the author and other details she recalled from her own experiences and those of other family members.
34. From Donnie Laas's written reminiscences, shared with the author on January 11, 2016. Used with permission.

Chapter 10

35. The National Register of Historic Places nomination form, housed at SHPO, includes one of the most complete historic overviews of the hot springs. An excellent article in the *Helena Independent Record*, August 29, 1982, also traces the history of the hot springs. Jeff Birkby's *Touring Hot Springs: Montana and Wyoming* (Guilford, CT: Globe Pequot Press, Falcon Guides, 2013) includes a short description. The Montana Historical Society's Research Center has a comprehensive vertical file on the property that includes various promotional brochures and pamphlets.
36. Senator James E. Murray's offer to donate the hot springs is reported in the *Helena Independent*, November 2, 1935.

37. Frequent advertisements throughout the decades are scattered through many of Montana's historic newspapers. The *Helena Independent Record*, October 20, 2011, reports several ghostly experiences at the hot springs.

Chapter 11

38. *A History of Carbonado and Boyd*, by the Joliet Wranglers 4-H Club, published as a comb-bound manuscript in 1980, provided the basis for this story. Artist Steve Miller wrote a short piece about J.P. Stormit— although he does not name him—to complement his sculpture *Ghost Horses*, manufactured by Montana Silversmiths and advertised online in 2010.

39. Mike Manweiler interview with the author, February 21, 2016, filled in many missing pieces of this story and provided the examples of other locals' experiences. A conversation with Joliet 4-H organizational leader Nellie Israel, February 22, 2016, also provided insight.

Chapter 12

40. The National Register of Historic Places nomination forms at SHPO for the Capitol Campus Historic District and the Montana State Capital provide building information and historic background.

41. Sam Jackson's accidental death is reported in the *Helena Daily Independent*, October 26 and 27, 1900.

42. Nicholas Kohr's death is reported in the *Helena Daily Independent*, December 25, 1900.

43. Victoria Hayden's *Rocky Mountain Spotted Fever: History of a Twentieth Century Disease* (Baltimore, MD: Johns Hopkins University Press, 1990) is an excellent historical overview of the disease and research efforts.

44. Dr. Cogswell's obituary appeared in the *Great Falls Tribune*, May 27, 1956, and many other state newspapers. The Montana Historical Society's Research Center library vertical file on Dr. Cogswell includes numerous clippings and tributes.

45. Interview with Joe Fisher, March 11, 3016.

Chapter 13

46. Author conversation with Linda Reeves, February 24, 2016.

47. Author conversations with Colleen Benjamin, May 2011.

48. Other stories about the haunting of the Belton Chalet, including that of the man in the brown derby, can be found in Karen Stevens's *Glacier Ghost Stories* (Helena, MT: Riverbend Publishing, 2013).

49. From Lee Cook's written account to the author, February 18, 2016. Used with permission.

50. The photograph of the Missoula County High School engineer is in the 1939 Missoula County High School yearbook, *Bitter Root*, housed in the Sentinel High School library. Interviews with Debby Davis and Frank Shepard were conducted at Sentinel High School on January 28, 2016.

51. Clara Bicknell Hodgin's life is told in *In Memoriam: Clara Bicknell Hodgin, December 30, 1870–January 14, 1905*, a small undated volume privately published by her family, housed at the MHS Research Center Library. The initial story of Clara's Grandstreet haunting is in Ellen Baumler, *Spirit Tailings* (Helena, MT: MHS Press, 2002).

INDEX

W

Walton, Ken 104
Weeping Child Hot Springs 17
wendigo 15, 16, 21, 22

Y

Yellowstone Lake 78, 79, 80
Yellowstone National Park 78
"Yellowstone whispers" 78, 79
Yogo Gulch 57
Young Mule, John 30, 33, 34

About the Author

Ellen Baumler received her PhD in English, history and classics from the University of Kansas, where she was a fourth-generation Jayhawk. She has been the interpretive historian at the Montana Historical Society in Helena, Montana, since 1992. She is a teacher and an extraordinary tour guide, and she is passionate about sharing Montana's lesser-known history. A longtime member of the Humanities Montana Speakers Bureau, Baumler's expert storytelling has delighted audiences of all ages and interests across the state. She is a 2011 recipient of the Governor's Award for Humanities and an award-winning author of many books and articles on diverse topics. She is best known for her spine-tingling, well-researched stories on Montana's haunted places.

Visit us at
www.historypress.net
..
This title is also available as an e-book